Problem Solving
for Oil Painters

To David Leffel, an inspiring teacher and a great painter,
whose commitment to a logical, conceptual approach to art
was the genesis for many of the ideas in this book.

Problem Solving for Oil Painters

Gregg Kreutz

Watson-Guptill Publications/New York

This book came about because of the help and interest of a lot of people. I want to thank Don Holden for contacting me and helping me with the preliminary outline, Bonnie Silverstein for helping to see it through, and Margit Malmstrom for her editing work. I'm grateful to my father, Irving Kreutz, and my friend Frederick Lunning for reading the manuscript and giving me their ideas. Getting photographs of the artwork was a big job, and O'Brien's Art Emporium in Scottsdale, Arizona, and the Fanny Garver Gallery in Madison, Wisconsin, were tirelessly helpful, as was Sherrie McGraw, whose help in assembling the artwork is much appreciated. Finally, I want to thank my wife, Gina, and my daughters Phoebe and Lucy for their help and enthusiasm.

Gregg Kreutz has been drawing and painting for as long as he can remember, but he did not pursue his interest in art with real seriousness until his mid-twenties. He had graduated from New York University with a degree in English and was working in New York as a musician when he wandered into a painting class at the Art Students League one day; he decided then and there to devote himself completely to painting. He subsequently won the League's Theka M. Bernay Memorial Merit Scholarship, and his work has continued to win honors ever since. Among his awards Mr. Kreutz has won the Advancement of Art Award from Allied Artists, the Catharine Lorillard Wolf Award and the Council of American Artists Award from the Salmagundi Club, the Grumbacher Award and the Medal of Merit (First Prize in Oil) from Knickerbocker Artists, and the Frank C. Wright Award from the Hudson Valley Art Association.

His paintings have been represented in many juried shows, among them, in New York, the Salmagundi Club, Knickerbocker Artists, Audubon Artists, and Allied Artists at the National Academy of Design, and in Flint, Michigan, at the Diamond gallery's "Man and His Influence" exhibition. He has also had numerous gallery shows and one man shows at the Fanny Garver Gallery in Madison, Wisconsin, at Grand Central Gallery in New York City, and at the Newport Art Association, in Newport Rhode Island.

Gregg Kreutz is represented by the Fanny Garver Gallery as well as by the Grand Central Galleries, New York, O'Brien's Art Emporium, Scottsdale Arizona, Gallery at Shoal Creek, Austin Texas, and the Dirk Walker Gallery in Birmingham, Alabama. He teaches painting at the Scottsdale (Arizona) Artists School, the Fechin Institute (New Mexico), and at the Art Students League in New York City where he lives with his wife Gina and daughters Phoebe and Lucy.

First published 1986 in New York by Watson-Guptill Publications, a division of Billboard Publications, Inc. 1515 Broadway, New York, New York 10036

Library of Congress Cataloging-in-Publication Data
Kreutz, Gregg, 1947-
 Problem-solving for oil painters. Pbk. ed.
 Includes index.
 1. Painting—Technique. I. Title.
ND1500.K74 1986 751.45 86-13238
ISBN 0-8230-4097-6

Manufactured in Malaysia

Paperback edition, first printing 1997

1 2 3 4 5 6 7 8 9 10 / 06 05 04 03 02 01 00 99 98 97

Designed by Jay Anning
Graphic production by Ellen Greene
Set in 10-point Century Old Style

Contents

Introduction

A great painting is a moment captured. It may have taken years to create, but its effect on the viewer is immediate. This quality of spontaneous vision can mislead the aspiring painter into thinking that art emerges full blown from the soul of the artist, or that the mark of true art is effortlessness. In fact, real art is more often than not the result of hard-won struggles with all sorts of problems, some lofty, some mundane.

Every good artist had to learn how to paint. Some may have taken to it more easily than others, but none just started out making great pictures. There are no child prodigies in painting. That's important to keep in mind, because it tells us that painting is learnable. It's not a gift from the gods. What's complicated is that its learnability doesn't involve memorizing a lot of rules or techniques. The artist develops by answering questions like, "What makes form look dimensional?" "How does light flow?" "How can air be represented?" and so on. Each painting creates questions and answers that apply not only to that specific picture but to all pictures.

In this book I've assembled some of the questions that have occurred to me during my years as a painter. Most of these questions came to me after I had been sitting glumly in front of my canvas trying to figure out why the painting wasn't working better. But they're not just "fix-up" questions. They are to be kept in mind throughout the painting, from beginning to end. "Does the painting have a focus?" "Is the subject effectively lit?" "Do the lights have a continuous flow?" These are concerns that should always be part of the painting process, from the very first brushstroke. When things go wrong, though, when the picture looks weak, one or two of these questions may help lead you to a way to make the painting better. And *better* is the important word here. A person learning how to paint needs to believe that "better" exists in esthetics. Cars, baseball players, and neighbors are evaluated and judged by everyone, but

when art is being discussed, relativity reigns: "I like this. You like that. Paintings aren't better than each other, only different." That kind of nonjudgmental spirit is fine for the nonartist, but it's disastrous for someone who's learning how to paint. If the beginning artist holds on to the view that, in esthetics, everything is of equal worth, then there's no such thing as improvement. All the neophyte can do is document personal moods and attitudes. Good art, however, is more than just a record of the artist's inner life. For it to be universal, it must represent a fusion between who is describing and what is being described. If the content is too dominating and the technique too superfinished and academic, the painting can look impersonal. If the artist is too dominating, too expressionistic, the painting can look self-indulgent.

If "better" is a real concept, the question becomes, "What are the attributes of a better picture? What makes one picture better than another?" Learning to paint means finding, as much as possible, the answer to that question. The characteristics of a superior picture are the same characteristics that you find in a good piece of music, or a good novel, or a good play. One of those qualities is *richness*. In a painting, that means a wide tonal range, with strong darks and vibrant lights. Another quality is *mystery*. If everything is too precisely rendered, the viewer isn't pulled into the painting. There should be unexplained passages for the viewer to fill in. Another quality is *design*. A good painting assembles disparate elements into a structured order. Each piece has a shape and design of its own that echoes the general design of the painting as a whole. *Simplicity* is yet another attribute of good art. Both the idea and the depiction of that idea must be simple enough to communicate forcefully. If there are too many ideas or too many variations on the single idea the picture can become diffused, a mere collection of artifacts.

Finally, the picture should have a *focus;* it should lead up to something.

Again, these qualities are not special to painting. Collectively, they define what all art is about. Painters are fortunate, however, in that they convey these larger ideas with very modest means. Unlike a playwright who has to wait for a producer, or a composer who depends on an orchestra, a painter can set up his or her canvas and go after the big issues without anybody else's help. That ease of production shouldn't trivialize the painter's attitude, however. A couple of hours spent painting is not simply a diversion. It's an opportunity to expand. And realistic painting is an especially rewarding endeavor. To actively go after it means to learn what makes art and what the external world really looks like and how the two can be fused. Learning to paint is an individual process, and every painter develops in his or her own way. The questions I have assembled here are just that: *questions*. They are not formulas or rules. Each of them, I believe, is valid, if sometimes only in a general way. I'm sure they could all be subject to exceptions, but in order to convey their *general* meaning and validity I've avoided qualifications. My goal wasn't to enumerate every possible option in painting, but rather to try and communicate some of the bigger ideas that I've found helpful.

About the example illustrations: Although the focus of this book is oil painting, the principles discussed are applicable to all mediums and might have been illustrated in any number of ways. But because I often had to show the reader an unsolved painting problem I chose to do small black and white charcoal sketches in many cases rather than full-size oil paintings. The charcoal gave me a quick way to illustrate a particular point and, equally important, it reduced the elements of paint quality and color that would have been peripheral to the central issues of value, balance, and other, more important, factors.

Part One

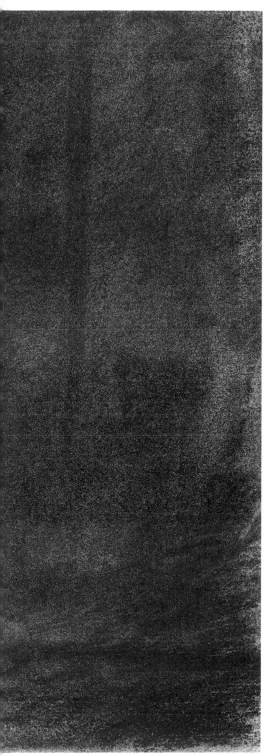

Idea

Painting realistically is not a mechanical act, and to the extent that it is, it will be unconvincing. That you can learn the rules of painting and then, cameralike, reproduce whatever you see on your canvas is a misconception that is partly responsible for the notion that only those painters who distort reality are using their creativity. In fact, turning reality into painterly effects requires not only creativity but insight and empathy. Learning to paint really means learning to be open to both the big effects and the small subtleties of the visual world, and further, to have ideas about what you're seeing.

To really capture the quality of a subject you must have a feeling about it beyond its literal qualities. To get it right you need to have an empathetic understanding of what you're depicting. Getting a likeness, for instance, requires much more than an accurate description of all the features. Representing the way someone looks means having some degree of sympathetic insight into the type of face being painted. You can measure the nose and put it down, measure the eye and get that in, and so on, but it's hard to imagine that this process could lead to a convincing illusion of reality or communicate anything about the essential, vital, and unique character of the person.

Copying, in other words, doesn't lead to a convincing, painterly picture. What is required is insight and perception. Each element in the picture must create an idea in the painter's mind, an idea that can be converted into paint. And collectively, all these ideas must serve the bigger, all-encompassing abstract idea that is the underpinning of every good painting.

Is There a Good Abstract Idea Underlying the Picture?

Every painting must have an underlying abstract idea, as well as its more obvious subject—in effect, it must have two subjects: the person or still life or view that you're looking at and the painterly concept that you have decided will best express your reaction to that person or that still life or that view. Both these subjects are related, and the painter's ideal is to unite them, to make form and content one. What you're painting has to be interesting enough to make you want to paint it. It has to be a catalyst to your thinking. It has to stimulate you to think thoughts bigger than, "Isn't that a picturesque house?" or, "What a great-looking face!" You need to find a painterly quality in the house or the face upon which to build a painting. You need to think in terms of larger ideas. For example: "This picture is about a brightly lit central subject surrounded by mystery," or, "This picture is about an orange foreground set against a green background." That kind of thing. You need some sort of controlling idea that will govern the choices you have to make.

In the still life on the top I tried to avoid imposing any sort of design or structure or concept. The pot, the cloth, and the apples are randomly placed in the rectangle, and consequently the picture has an arbitrary look. In the still life on the bottom I tried to use the props to create an image, a visual event. I didn't merely change the composition, I tried to assemble all the elements—value, light, shapes, negative space—so that the picture would look like *one thing*, a unified whole.

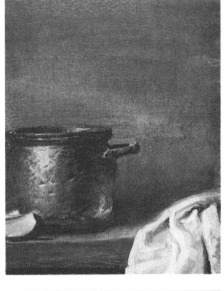

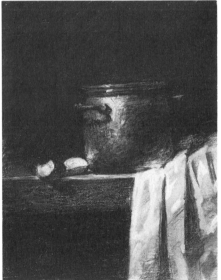

BURNING TRASH. 20″ × 38″ (50.8 × 96.5 cm).
Collection of the artist.

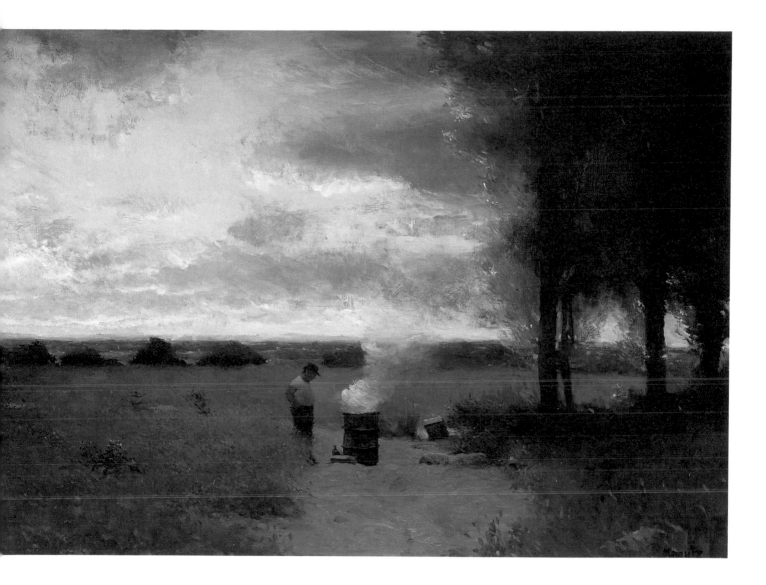

BURNING TRASH

This painting illustrates what I mean by there being two subjects that the painter must paint. The obvious first subject is the man burning his trash at dusk. This activity has meaning for me because when I was a kid I always enjoyed lugging trash out to the burning area and watching it light up. So one of my main goals was to get the gesture and attitude of the man as he stood there.

The second subject of the painting is harder to describe. I wanted to see if I could take a harsh geometric composition and fill it with depth. I divided the canvas almost in half and blocked off a quarter of the upper half with dark tree shapes. There were then basically three rectangles:

the land area, the sky, and the large trees. The task turned out to be: how much information could I put into each of these rectangles without sacrificing the simplicity of the design? Too much light on the land would weaken its impact as a dark, too many darks in the sky would undermine the sunset brilliance I was after. The element that unites the three areas is color. A red glow permeates the whole picture, establishing that everything in the picture exists in the same place at the same time. The casual act of staring into some burning trash has been given deeper meaning by placing it in an esthetically formal context.

What Details Could Be Eliminated to Strengthen the Composition?

The more cluttered your picture, the more difficult it is to read as one simple statement. As you're painting, it's tempting to keep adding things; big stretches of bare canvas beg to be filled, particularly if the center of interest doesn't seem that compelling. Filling in those blanks, while it can give density to the painting, doesn't help strengthen its impact. In fact, the more clutter, the weaker the image.

As your painting progresses, if parts of the canvas look bare or neglected, instead of adding things to the setup try strengthening the central image. This may not be the most obvious solution because the central image may be painted perfectly well. But in a painting, accuracy isn't enough; intensity is the goal. If a figure in a room is depicted in a credible way, it's easy to say to yourself, "Good, that's over. Now I'll put in all the other stuff." But that's the wrong approach. It's valuing things over ideas. It's thinking of the picture as a collection of objects instead of as an expression of a concept.

The still life on the top shows a composition where the center of interest isn't really interesting enough. The still life in the center shows what I think is a bad solution to the problem. Adding another vase to the proceedings doesn't really help matters. True, it does get rid of the feeling of blankness, but I don't think the picture has gained anything in terms of power. The still life on the bottom shows a better solution to the problem. By intensifying the lights, deepening the background, and putting some reflected light in the shadow, I got an image interesting enough to keep the viewer's eye from wandering into the unfilled areas.

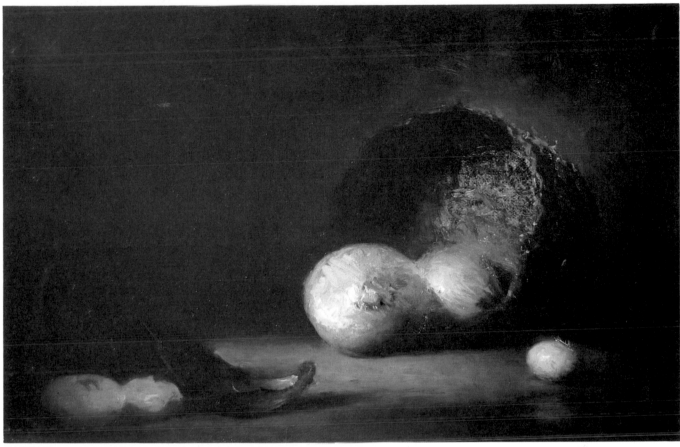

ONIONS. 10" × 15" (25.4 × 38.1 cm). Collection of Cary Ennis.

ONIONS

Here, the goal was to make the central orange-colored onion as compelling as I could. I put almost everything else into shadow. Rather than describe the weave of the basket too carefully, I used the grain of the canvas to suggest its texture and thereby kept most of the interest on the central onion.

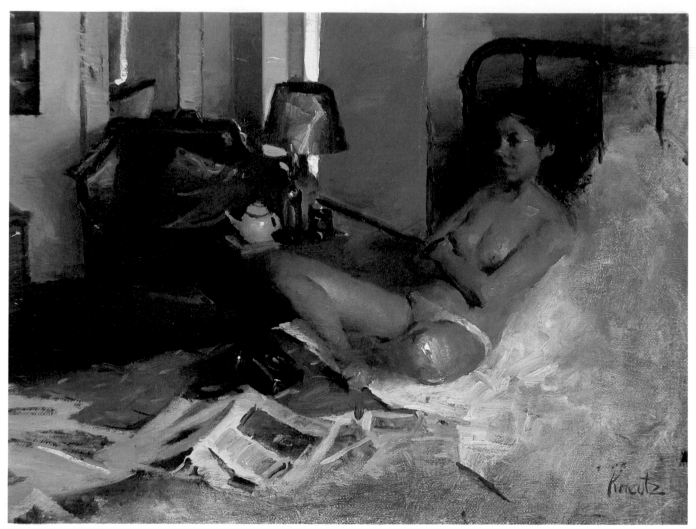

SUNDAY MORNING. 12" × 16" (30.5 × 40.6 cm). Collection of Richard and Anne Arnesen.

SUNDAY MORNING

There was so much going on here—so much content—that I felt I had to let some part of the painting remain undefined. I could have underpainted the righthand material, or thrown it into shadow, but I liked the way the newspaper and sheets look as though they're growing out of the canvas. This was an on-the-spot painting, and consequently the lighting wasn't very controllable. The model, the bed, and the bedside table are frontally lit, while the chair in the back is lit by the little opening in the shaded window.

Does the Painting Have a Focus?

Some part of the painting should clearly represent the central focus of the picture. How it is stated and what devices you can use to make it clear that it *is* the focus are things I will be talking about throughout this book. But the main thing is to *have* a focus. Without it, the painting is just a collection of artifacts. With it, the picture looks like a picture, a visual event. Sometimes the center of interest occupies that position because it is different from what surrounds it, sometimes it holds attention because it is the culmination of the rest of the elements in the picture.

Painting with your eye always on the center of interest helps keep you from merely copying and putting equal attention on all the elements of your subject. While you want to be true to what's out there, you also have to be true to the way human beings actually see. When we look at something we always look at *some thing*. No matter how general the vista, how nearly empty or how cluttered, we always pick out something to focus on. Try looking across the room without selecting something to zero in on; I don't think it can be done. Paintings should be no less selective than our eyes are. When we look we don't see everything with equal clarity. Our paintings should exhibit the same discrimination, the same variations in intensity.

The still life on the top shows a setup without a clear focus. You can't tell which of the two pots is of greater interest to the artist. In the still life on the bottom, I used just one pot, and as a result it looks more like a picture. If I were to pursue this picture any further, I would try and figure out other ways to make the pot more compelling.

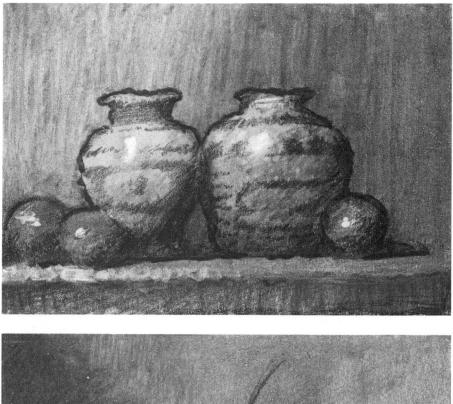

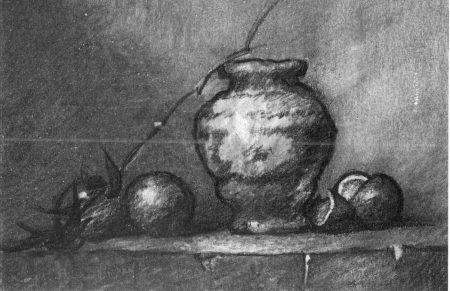

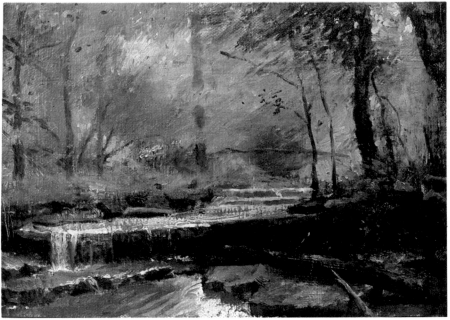

JORDAN RIVER. 9" × 13" (22.9 × 33.1 cm). Collection of Bernard and Toby Cohen.

JORDAN RIVER

The little waterfall is the obvious focus in this painting. If it weren't there the picture would look empty. Because this was painted on a very small canvas, I was able to complete it in one afternoon. Outdoors, I find that I usually have to work small if I want to get to any kind of finish in one sitting. Working larger and coming back a few times is often unfeasible because the light can vary so much from day to day.

IN THE STUDIO

I actually began this painting as a simple picture of the way my studio looked, sort of an homage to clutter. But even with all the props, the painting seemed too vacant. So I put up a mirror and painted myself looking down (no easy task), thereby providing a focus for the picture. That's sort of a backward way to get at an idea for a painting (it's obviously better to get your focus organized at the beginning), but oftentimes you can't tell what the nature of your picture will be until you get it started.

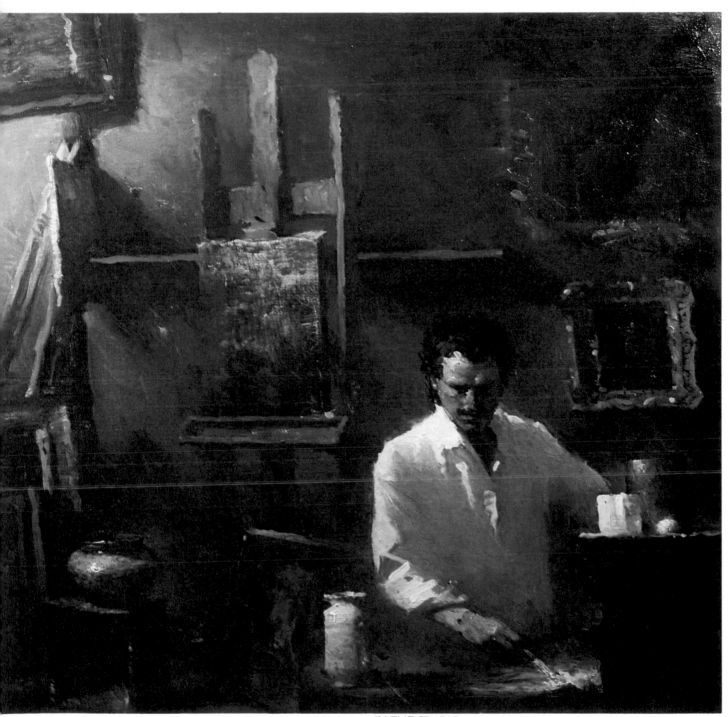

IN THE STUDIO. 12″ × 20″ (30.5 × 50.8 cm). Collection of Andrew Bell.

Are the Unessential Parts Subordinated?

When it's clear in your mind what the focus of the painting is, the next problem becomes how to underplay the other elements. Having that problem, or any other problem, to solve actually makes the picture easier to paint because it makes you look functionally at what is being depicted. You're no longer just trying to get it to look right. You're trying to fit it into your scheme of what's important in the picture. The picture is primary. Nothing should go into it that doesn't make it a more intense visual event.

One way to subordinate the unessential parts of the picture is to underpaint them, to depict them less precisely. Another way is to allow parts of the picture to remain in shadow. In the still life on the top I rendered everything with equal intensity; nothing dominates. In the still life on the bottom I wanted to stress the pitcher so I only vaguely suggested the straw weave of the basket and threw the lefthand lemons into shadow. Not only do shadowy areas force the viewer to look at the focus (the eye always looks toward the light), but they also provide mystery and help soften any cold or literal feeling a painting may have.

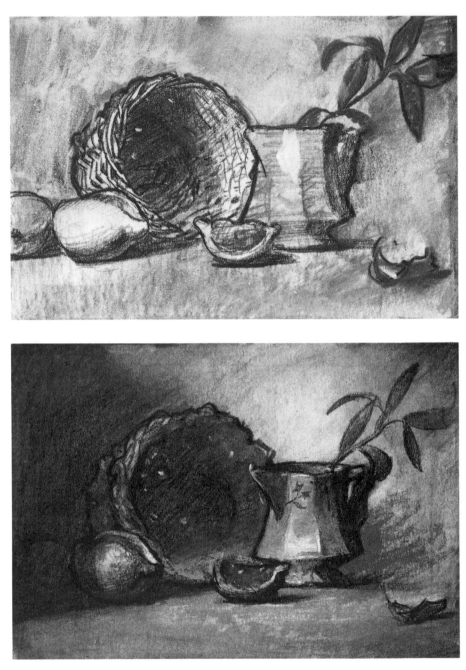

Demonstration: Underplaying the Background

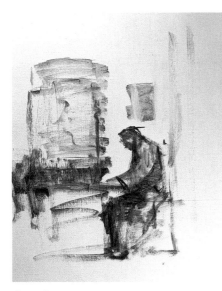

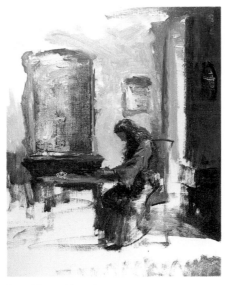

Step One. I begin the picture with broad suggestions of the main shapes. Placement is the major concern here, but I'm also trying to figure out what the painting's color world will be.

Step Two. Here, I try to get a vague sort of look for the back wall. Because the figure is the main focus, I want to underplay all the peripheral material.

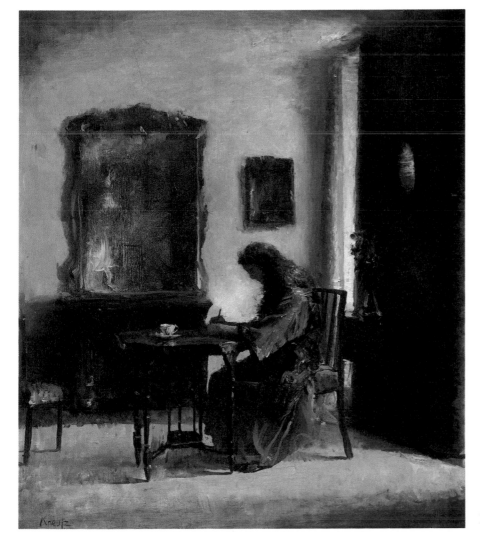

Step Three. After finishing the background, I move in on the figure, and get her as finished as I feel she needs to be. I wanted a shimmering, temporary look for this painting so I've consciously kept everything pretty loose. The setting here, by the way, is a large hotel in Cornwall, England. The proprietress, Ellen Fleming, kindly allowed me to set up and paint in one of the sitting rooms. That's her daughter in the chair.

ANNE AT THE TABLE. 26" × 16" (66 × 40.6 cm). Collection of Elizabeth Kreutz.

Does the Painting "Read"?

That is to say, is there a route the viewer can follow to the center of interest? How the picture "reads" is based on how the picture is designed. In Western culture we read text from left to right, and consciously or unconsciously, we tend to read paintings the same way. For that reason, it's not a good idea to put the object of greatest interest on the left edge of the canvas. Of course this doesn't mean that *all* pictures have to read in the same way. There are other routes through a picture, as the paintings on the next two pages show.

A picture's readability is also enhanced by having the light flow in the same direction that our eye is moving. This device makes the route to the center of interest even more compelling.

In the still life on the top I placed the focal point on the left side of the composition, and the picture doesn't work. What happens is that our eye starts traveling across the picture, comes to the coffeepot, and stops. There's no reason to look any farther. The main event happens at the very beginning of the show. The setup on the bottom makes more sense. It reads. Our eye travels over the space and then settles on the coffeepot; we move through the picture toward a goal.

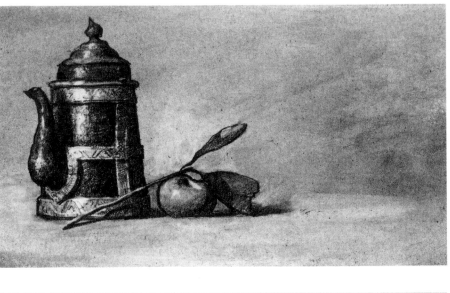

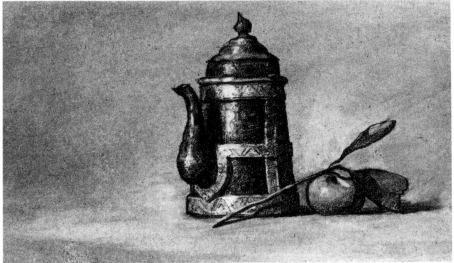

WISTERIA

I wanted to showcase the wisteria that had just bloomed over our neighbor's front door, so I put a shadow over the lower part of the canvas and intensified the light around the blossoming focal point.

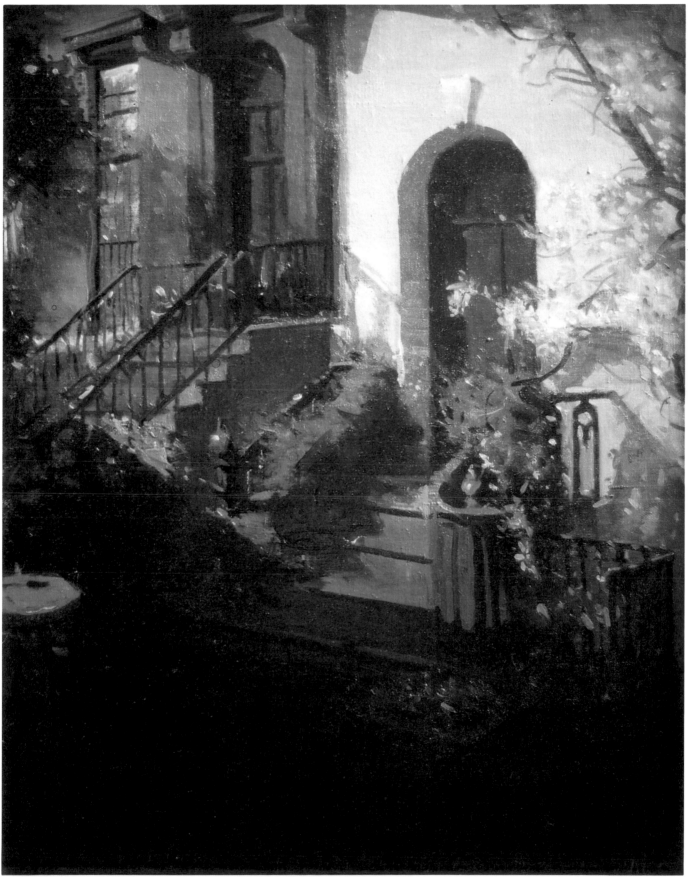

WISTERIA. 40" × 30" (101.6 × 76.2 cm). Collection of Joan Potter and Dr. Diego Alvarez.

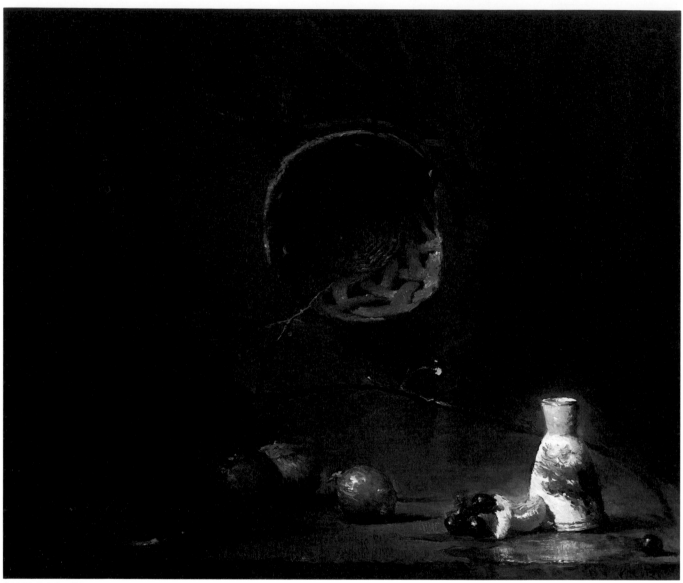

SAKE PITCHER. 20″ × 30″ (50.8 × 76.2 cm). O'Brien's Art Emporium.

SAKE PITCHER

This picture required restraint on my part to keep the peripheral parts from becoming too dominant. The basket, for example, had to be subdued by floating background color into its shadow area, and the carved figure was made into a stark silhouette so that it wouldn't distract from the main event, the sake bottle.

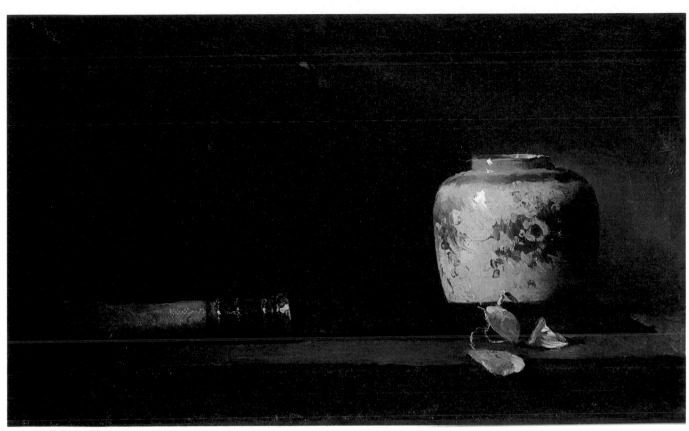

SILVER DOLLARS. 8" × 13" (20.3 × 33.1 cm). Collection of Dolph Jeffery Stanley.

SILVER DOLLARS

Here is a simple left-to-right setup. I used a knife as the agent of direction, leading the viewer toward the little pot. The "silver dollars" are there to make the center of interest stronger and to add a touch of delicacy. Mainly, I was trying to make the arrangement look good. But at some level I was indeed structuring the picture in a way that would make it readable.

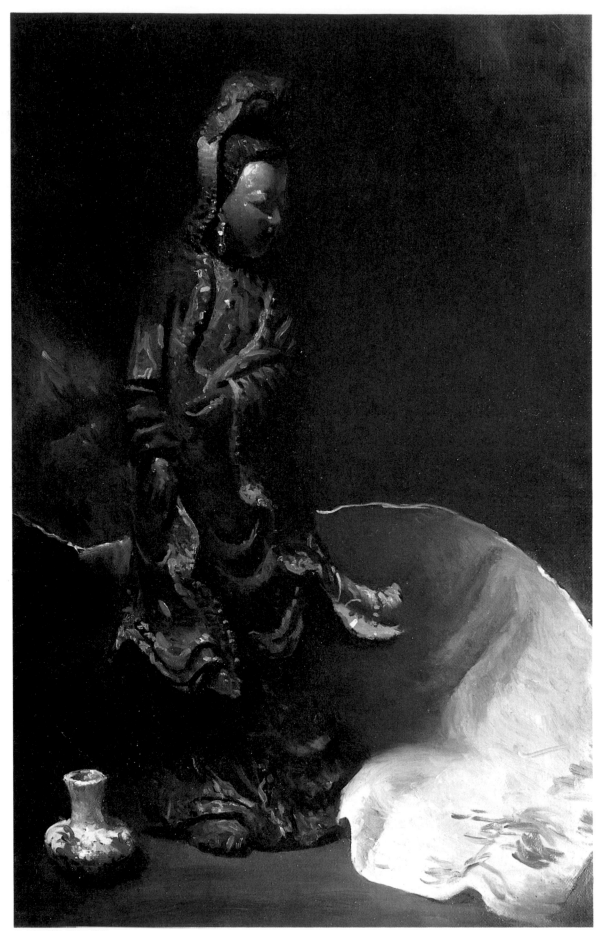

CHINESE FIGURE. 20″ × 14″ (50.8 × 35.6 cm). Collection of Col. and Mrs. Allen L. Peck.

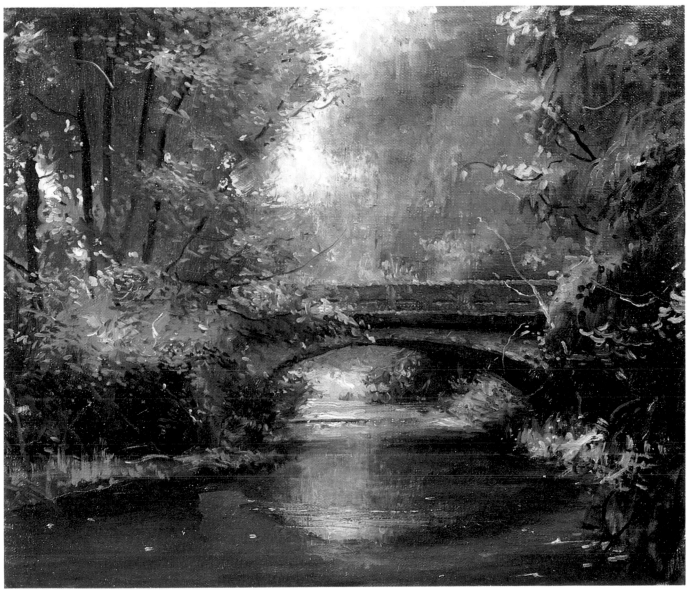

BRIDGE ON CASTLEMAN'S RUN. 18" × 20" (45.7 × 50.8 cm). Grand Central Art Galleries.

CHINESE FIGURE

This picture is meant to read from top to bottom. My idea was to start the picture at the head, follow the drape as it curves to the lefthand corner, and end at the little vase.

BRIDGE ON CASTLEMAN'S RUN

This painting isn't reading left to right; it's reading near to far. Your eye follows the river into the picture and ends up at the yellow grassy bank past the bridge. I painted this picture on the spot. It struck me as a "view-through" kind of composition: the bridge functioned as a window, framing the light bank downstream. Having that perception kept me on track and made painting the picture easier. I was not simply copying what I saw, I was putting everything in the service of my idea.

Could You Finish Any Part of the Painting?

The intensity of a picture is an echo of the intensity with which it was painted. Your attitude toward the worth of your efforts will show on the canvas: if you're indifferent, the picture will be uninvolving. You don't have to think *you* are great, but you do need to feel that what you're *after* is great. You need to feel at every moment that the canvas could come alive, could become a beautiful picture. To think that way raises the stakes. It gives weight to what you're doing and increases your concentration. You shouldn't be held back by the thought that you're not good enough, not experienced enough. That's always going to be true: no artist is as good as he or she could be; that's what keeps us painting. You need to feel that despite whatever limitations you have, you have enough vision and feeling to create something artistic and that that creation can occur *right now*. The extent to which you feel that your picture is just an exercise or preliminary study, to that extent will your picture fail to become a *painting*.

A pragmatic way to get into the picture—and I believe attitude grows out of action more often than the other way around—is to get something on your canvas finished. That is to say, pick an area and resolve it as best you can: all the color, edge, value, and paint quality problems that exist in that area. Once something in the picture is really nailed down, the potential of the picture will reveal itself more clearly.

Getting a vision of where you're going makes getting there a lot easier. Putting some of the finish in early allows you to visualize what needs to be stressed and what can be underplayed. It often happens that you finish some significant area in the early stages of the painting, only to discover that the picture is done, that the one completed area makes the rest of the picture look either finished or intentionally unfinished.

In the still life on the top nothing is finished. Value, edge, and placement are only approximated. That treatment is alright for the beginning stage, but to carry the picture farther there has to be some resolution, some commitment. In the still life on the bottom, simply by finishing a few pertinent areas I've made the picture look like a complete statement. For example, defining only the outer, lit edge of the Japanese wine bottle makes the whole bottle look finished, as does refining the upper lip and lower stem of the sake cup. Etching the black spout of the teapot more crisply against the white bottle makes the whole pot look more defined. A small amount of finish is often all that's needed to make the whole picture look completed.

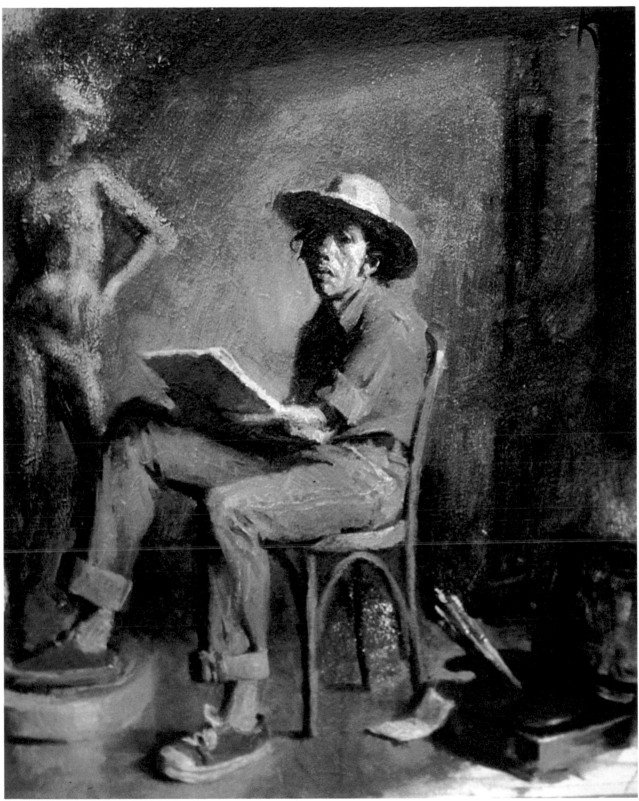

ALBERT SKETCHING. 20" × 16" (50.8 × 40.6 cm). Private collection.

ALBERT SKETCHING

Here, Albert is painted pretty carefully, and because of that the eye accepts the blurry vagueness behind him; the finished foreground permits a looser background. Often when you feel that the background is "unfinished" and lacking in detail, what the painting really needs is more intensity in the foreground.

I painted this picture when I was in art school, and I think this guy pretty well epitomizes my feeling at the time: grimly determined.

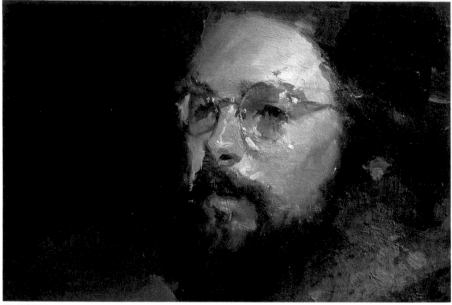

RUSSELL. 15" × 10" (38.1 × 25.4 cm). Private collection.

RUSSELL

Here's an example of a little finish making up for a lot of unfinished area. Everything is pretty vague except for Russell's left eye and his nose. Those are so carefully done that they make the whole head look like it's complete. I had planned to get Russell to come back so I could finish the painting, but after awhile I decided I liked it the way it was.

DEVIL'S RIVER

Finishing something in the picture is useful when you're trying to simplify a complicated passage. The bushes here seemed impossibly tangled and dense, but I found that by refining and delineating the one lit group of leaves in the center all I needed for the rest was a transparent wash of yellow and burnt sienna.

DEVIL'S RIVER. 14" × 18" (35.6 × 45.7 cm). O'Brien's Art Emporium.

Part Two

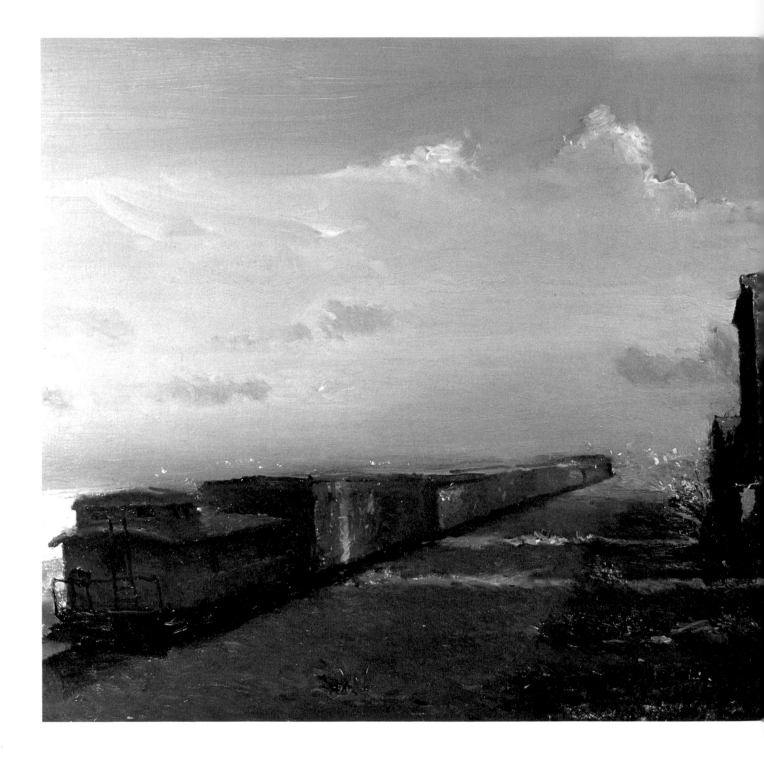

Shapes

Shapes are essential tools for the painter. They are just as important as color or dark and light in the composition of a painting. A good picture is a mosaic of appealing shapes. The shadow shapes and the negative-space shapes should be as carefully designed as the light shapes. That's one of the things that separates paintings from photographs. Everything in a painting can and should be designed for optimum beauty and impact. Nothing need be arbitrary.

The representational artist turns external reality into a collection of shapes. Three-dimensional volumes must be represented by flat areas of paint, and in the beginning stages of a picture those flat areas need to be placed on the canvas according to the abstract pictorial needs of the picture. A person sitting in a chair, for example, shouldn't be carefully copied onto the canvas at the beginning; instead, the subject should be converted into a general abstract shape—a triangle perhaps—and then placed where it will create the desired pictorial effect. As the painting progresses, that triangle will be refined into smaller and more precise shapes until all the areas work together to form an interrelated whole.

Are the Dominant Shapes as Strong and Simple as Possible?

Simple shapes carry. And big simple shapes carry best of all. One of the goals that most painters have in common is to make their pictures readable from across the room. You don't want the design and content to disappear at fifteen feet. For that reason, it's a good idea to organize your picture in terms of clearly stated shapes. The way each shape connects to its adjacent shape should vary throughout the picture, but the integrity of each shape must be maintained.

If you're painting a head, for example, don't document too rigorously all the ins and outs of muscle and bone that occur along the edge of the face. The primary statement is the simple contour describing the simple oval. The in-and-out topography along the edge is best conveyed with varying degrees of sharpness in the line.

The picture on the top was conceived from the beginning as a simple light shape surrounded by dark. On the bottom, I've reduced the image to its bare essentials so that the abstract concept of light against dark is clear. The difference between the two is one of nuance. There's more subtlety in the top picture, but the basic statement is the same.

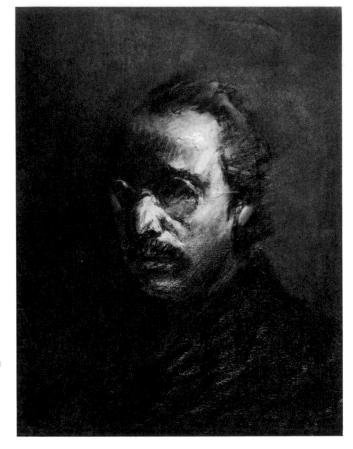

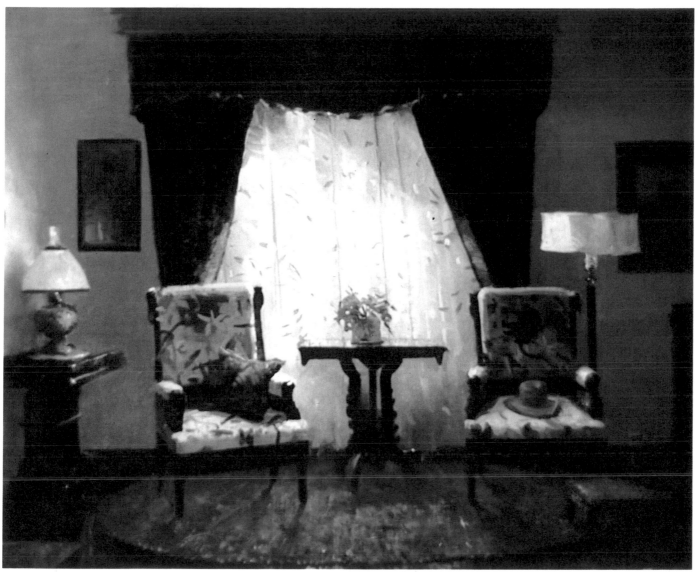

FARMHOUSE PARLOR. 20″ × 30″ (50.8 × 76.2 cm). Collection of John and Fanny Garver.

FARMHOUSE PARLOR

I used the window as the big shape here, with the hope that it would unify the smaller elements in the painting. The hard thing was to look into the light and then refocus my eyes on the canvas. It was difficult to get the values and the color right with all that readjusting.

LOBSTER BOAT. 8″ × 10″ (20.3 × 25.4 cm). Private collection.

LOBSTER BOAT

Here, the dominant shape is not a light shape but a dark one. The boat, its reflection, and the pilings are framed by the light, forming a sideways **L**. For the idea to work, I had to keep the darks dark and not go too high up in value within the focus area. I started the picture pretty much in the center, trying to get the boat's blue color right, and then working out the sky/sea color next to it. When I first put in the suggestion of the pilings, I had intended to finish them more carefully, but I liked the way they looked unfinished so I left them that way. I still like them even though it's not especially clear what they are.

Demonstration: Starting a Painting by Blocking in the Basic Shapes

Step One. This is how I usually like to start my paintings: just a rough block-in of the basic shapes, broadly described, without too much concern for getting their perimeters exactly right. My main interest at this point is the design; I want to make sure everything is positioned on the canvas in an esthetically pleasing way. The picture is going to end up having a light-against-dark composition, but because the canvas is white, the only way I can see the shapes is to render them with dark paint. In a sense, I'm painting a negative of how the picture will eventually turn out.

Step Two. I've roughed in the background here. Now I can get a better idea of the true light-against-dark quality I'm after. Because of the nature of lead-primed linen canvas, it's hard to get solid paint coverage with the first coat. The background that I've put in is a little too thin to suggest density, but the value looks right so I'll just leave it alone until it dries. As a way of getting the real painting going, I've blurred in some of the red of the apple and some of the blue of the cloth.

(Blocking in the Basic Shapes continued)

Step Three. The paint has dried enough by now to allow me to put in a more solid, more air-filled background color. I paint the pot in two distinct steps: first, I paint the ground color of the pottery—in this case a greenish white—over the whole pot and let it dry; then I glaze in the blue pattern with ultramarine and a lot of medium. My hope is that this approach will best capture the pot's bleeding-glaze surface. Usually, I like to paint everything in directly, but with a pattern this complicated it seemed easier to break it into stages.

Step Four. I've painted the pot, the apple half, and the cloth almost all at once, and from here on in it's a question of refining what I've got into a coherent picture. Still lifes are sometimes easier to paint than other subjects because (ideally) you've solved a lot of your problems before the painting starts. When you set up a still life you can organize it so that the light flows and the colors read the way you want them to. Painting your setup becomes merely a restating of your vision.

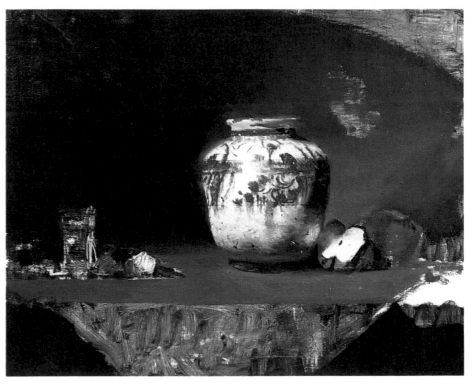

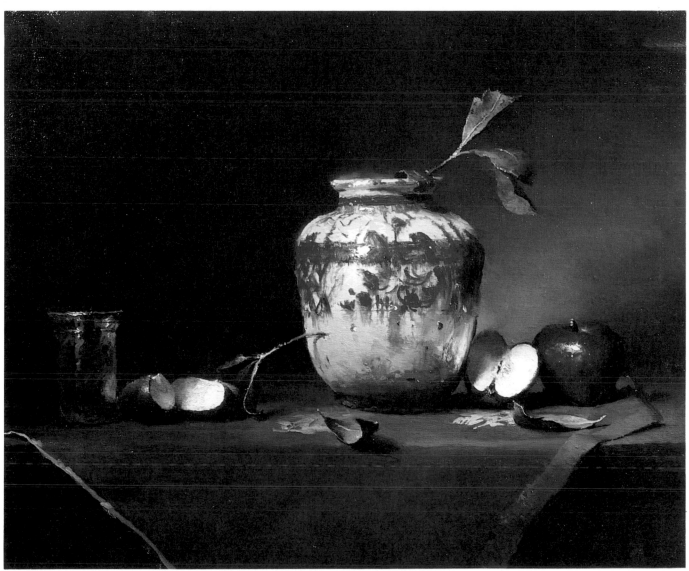

STILL LIFE WITH PERSIAN VASE. 24″ × 30″ (61 × 76.2 cm). Private collection.

Step Five. Aside from painting the rest of the elements in the setup, my goal at this finishing part of the picture is to make the center of interest as intense as possible. One way I thought of to do that was to increase the reflected light on the pot. It makes the light look more intense and it also makes the light area bigger. I've also used the leaves as a way to surround and frame the center of interest.

Are the Shapes Too Similar?

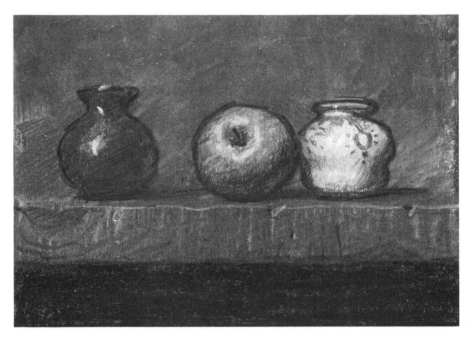

In many ways, a painting is a synthesis of opposites: light and shadow, warm and cool, sharp and soft, coarse and fine. These polarities, when integrated into the picture, create vibrancy and dynamism. If everything in the painting is warm, the picture will have a hothouse look. If everything is coarsely painted, the eye is given nothing to settle on. If everything is finely painted, too much information will confuse the viewer. Putting in the opposite of each of its qualities will open the picture up and expand its range.

Shapes need this polarity as well. Having all the shapes the same size robs a picture of scale; the viewer can't tell how big or small anything is. Also, having all the shapes of a similar type can look monotonous.

I'm not saying, of course, that every quality in a picture should be evenly matched with its opposite. The painting needn't be equal parts warm and cool, or half dark and half light. You may want to have a general warm tonality surrounding a small cool area, or a generally light picture punctuated with smaller areas of shadow or dark tone. The distribution of opposites doesn't have to be even, just evident.

To get back to the problem of shapes, I've set up the still life on the top with objects of almost identical size. In the still life on the bottom I got some new props that show size variety. The second still life looks more like an event: esthetically, something is going on in this picture.

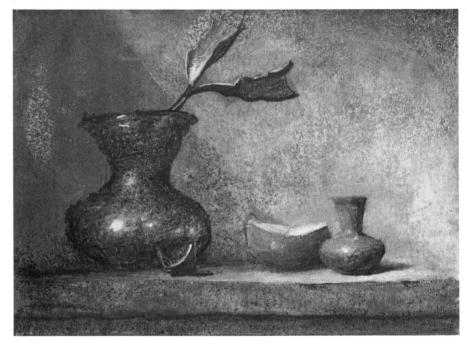

THE FOUR SEASONS GINGER JAR

The contrast here is between the big pot and the (relatively) small apples. Without the apples, you wouldn't be able to tell how big the pot was. Their presence along the tabletop gives a looming sort of drama to the pot. The picture, incidentally, also illustrates some other polarities: the fineness and elegance of the detail on the jar contrast with the mundane homeliness of the apples; and the color scheme is an examination of complements—green against vermillion; the warm yellow of the apple against the cool green of the rest of the picture.

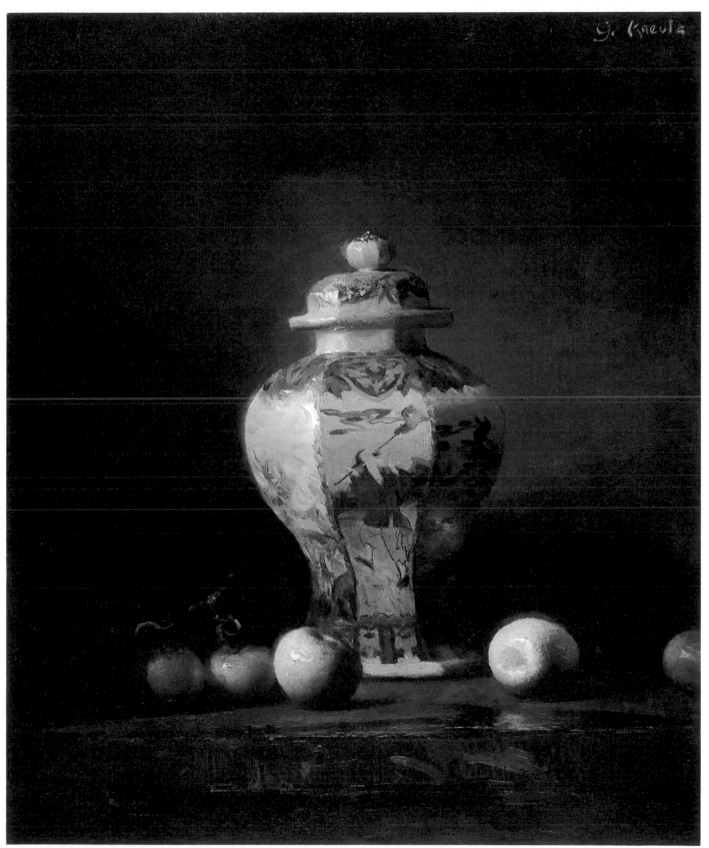

THE FOUR SEASONS GINGER JAR. 24″ × 18″ (61 × 45.7 cm). Collection of Charles and Martha Casey.

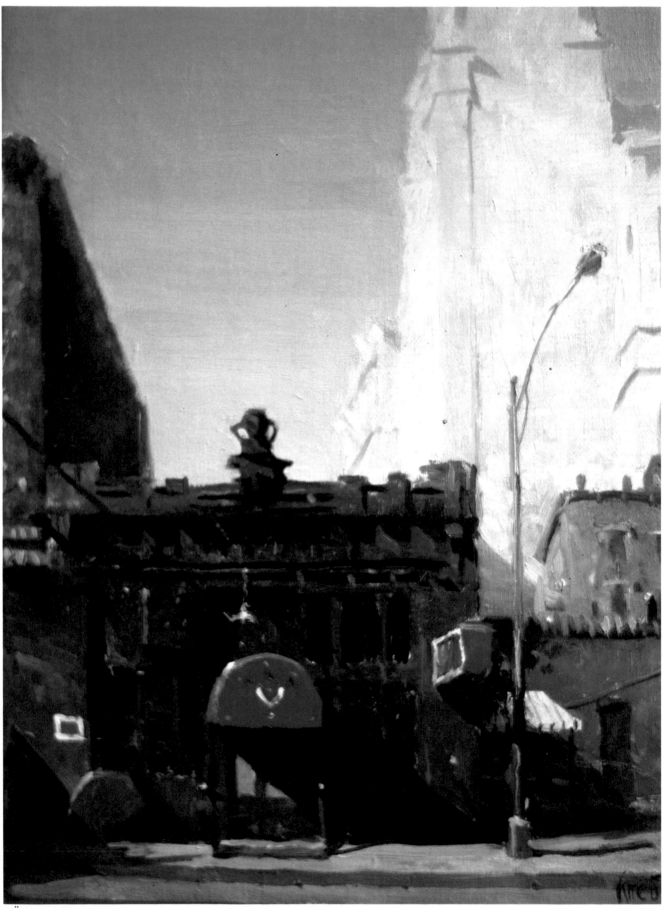

LÜCHOW'S. 16″ × 12″ (40.6 × 30.5 cm). Collection of Paul Reiss.

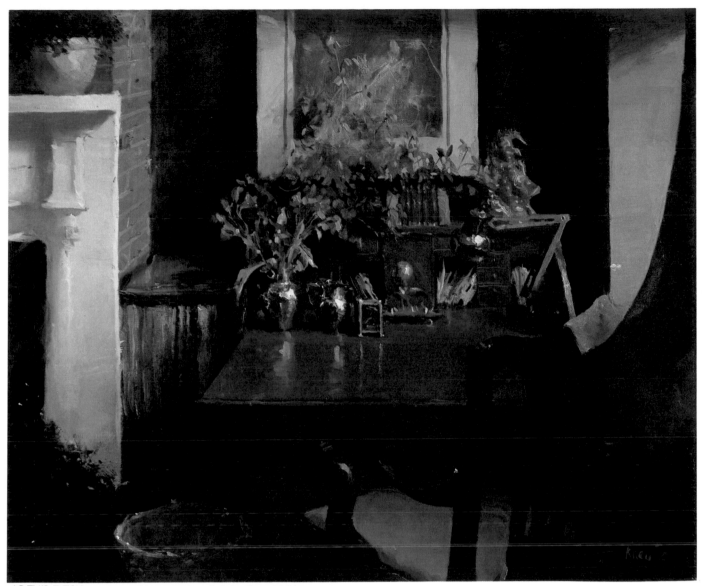

JOEY'S DESK. 24" × 32" (61 × 81.2 cm). Collection of S.J. Lenerz.

LÜCHOW'S

This picture was painted on the spot. What attracted me was the contrast between little Lüchow's and the big Con Edison building behind it. Looking at the picture now, I feel I could have stressed that contrast a bit more, but sometimes when you're painting outdoors, you're so frantically trying to get everything in before the sun goes away, or a truck parks in front of you, that you lose sight of your original concept. What you gain, however, is some intangible reality, some true-to-life quality that's missing if you paint from photographs. I've painted a few landscapes from my imagination in the studio, and that seems to be a good way to hold on to your original concept. The image you have in your mind doesn't get interrupted by dissonant elements unrelated to your idea. The only problem is that sometimes you miss the extra stimulation that comes from **real** things.

JOEY'S DESK

I wanted to counter all the little delicate things on the desktop with larger surrounding shapes, so I draped the window curtain over the chair and moved a potted plant over to fill in the lefthand corner.

Part Three

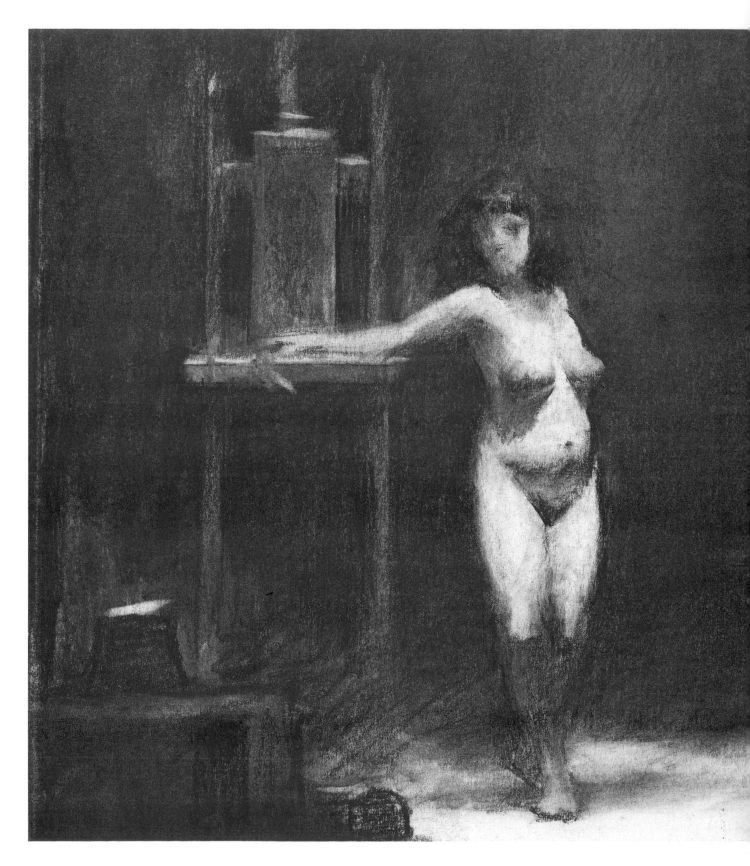

Value

Value refers to how light or how dark something is. It's what shows up when a color painting is reproduced in black and white. The sharpness or intensity of the color doesn't have any bearing on its value. An apple may be a pure, vivid red, but its value will probably be just a middletone gray. That's important to understand because you can be fooled into painting vivid colors in a high key. You need to figure out the value—not just the color—of each thing that you paint.

The best way to determine a subject's value is to compare one value with another. For example, if you're painting a portrait of someone in a white shirt you can gauge the flesh color in light by checking out how much darker it is than the shirt in light, and how much lighter *it* is than the hair in light, and so on. In painting, nothing is true in isolation; the accurateness of a passage depends on its relation to an adjoining passage.

Correctly analyzing value is often complicated by the eye's ability to adjust itself to varied light conditions. When things darken, the eye accommodates and the pupil dilates. This creates complications, because if a painter is trying to determine the value of a shadow area and his or her eye is adjusting to that shadow's darkness, the value will seem to rise, to get brighter. The more you look into darkness the brighter it gets. The solution, again, is to find the value through comparison rather than guesswork. Is the shadow on the face lighter or darker than the background? Is the hair in light darker or lighter than the flesh in shadow? That kind of comparative analysis roots the picture in external reality.

Could the Value Range Be Increased?

Beautiful things can be done with middletone; it can be a nice stage upon which to play out a subtle, carefully nuanced effect. But for vivid drama and chiaroscuro excitement a strong contrast is needed between the lights and the darks. Contrast—one element pitted against another—is what gives a picture its tension. For that contrast to be effective, the two end values must be made distinct from each other. The light needs to be light and the dark, dark.

This is hard; both human nature and the nature of paint work against it. Psychologically, getting a wide value range on the canvas is difficult because contrast draws attention to itself. An artist who lacks confidence may want to avoid the scrutiny that a higher value range invites and stay in a safe middletone where drawing weaknesses and compositional failings seem less glaring. Also, the artist may feel that since there is no vivid contrast the picture seems to hold together; it looks tonally unified. But this is negative unity. The picture holds together only because nothing is going on that's exciting enough to pull it apart.

The very nature of oil paint also conspires to keep the values in middletone. Wet-into-wet painting, as important as it is for a painterly look, tends to dull things down. A light tone brushed over a darker one gets a little dirtied and a dark tone brushed over a light one loses its richness. Applying less pressure on the brush helps modify this effect, but sometimes there's nothing for it but to wait until the paint dries and then put the desired brighter (or darker) tone on the canvas. The important thing is always to be aware of the option of increasing the value range. When a dark or light is firmly stated, it's easy to be fooled into thinking that that's it. But as someone once said, "You don't know what's enough until you've done too much." If it looks bright, see if it could be brighter. A picture gets exciting when it looks as though it's been pushed to the limit, as though every-

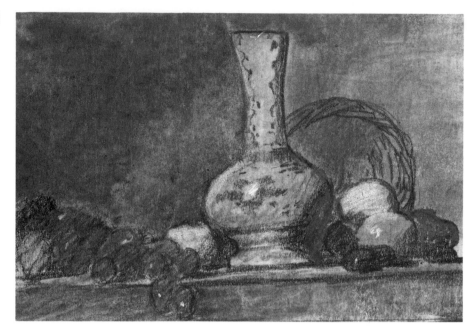

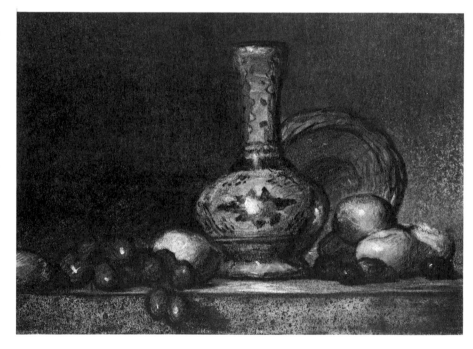

thing is as dark or as bright or as colorful or as mysterious as possible.

In the still life on the top I kept everything close to a middletone. In the still life on the bottom, I made some of the darks darker and the lights lighter. Watching the picture get richer by widening its value range is one of the pleasures of painting.

IN THE ATTIC

Most of the objects here are not very brightly lit, so the only way to show them off was to deepen the background as much as possible. I ended up using a mixture of black and burnt sienna, which created the needed contrast.

I painted these things pretty much as I found them in a farmhouse attic, and to me they're suggestive of a time gone by. While I was doing the painting, however, their chief attraction was the way their textures interacted with the flow of light.

FLORIDA CEMENT PLANT

The best way to capture the brightness of this tower seemed to be to darken the sky behind it. That value shift tells us how high in key the tower really is. It's tempting when confronted by these brightly lit scenes to paint everything in a high key, but that can create a bland rather than a vivid look.

IN THE ATTIC. 12″ × 16″ (30.5 × 40.6 cm). Collection of Mark and Miriam Owen.

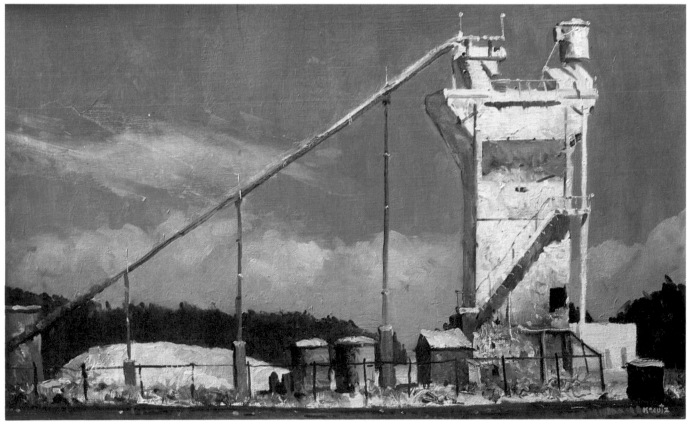

FLORIDA CEMENT PLANT. 14″ × 20″ (35.6 × 50.8 cm). Collection of Jack Latrobe.

GULF STATION AT DAWN. 20″ × 16″ (50.8 × 40.6 cm). Collection of Howard and Caroline Lippincott.

CORNER COFFEESHOP. 18″ × 14″ (45.7 × 35.6 cm). Collection of Charles Harding.

CORNER COFFEESHOP

This painting has an overcast light effect, and I used something close to black for the underplanes. I pushed the brightest light as high as I could on the man's silver flight jacket.

That's actually my jacket, which I painted in after I was back in the studio. I put the jacket on and painted it by looking over my shoulder at the mirror in order to get a back view. I went to that trouble because I felt that the picture needed something dynamic and compelling, and a bright light effect seemed to do the job.

GULF STATION AT DAWN

I needed a wide value range to make this fairly complicated light situation make sense. The sky is lit, but in middletone because I wanted to save my highest value for the electric light. To accent its brightness I kept the building's value way down, going to almost black in the underplanes. With so much going on, I decided to reduce the distant structures to a simple silhouette of darker middletone.

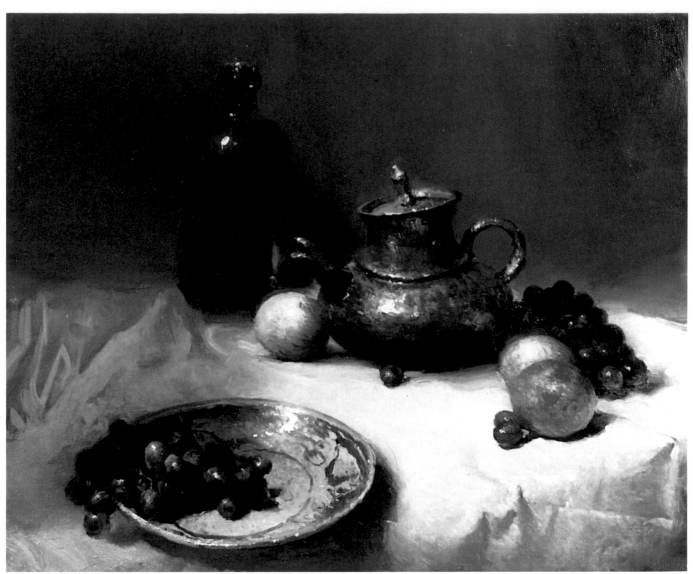

ON THE WHITE TABLECLOTH. 18″ × 24″ (45.7 × 61 cm). Private collection.

ON THE WHITE TABLECLOTH

I wanted to paint a still life that had a vivid look, so I selected material and objects that when grouped together would create a high-value range. Juxtaposing a white cloth against dark objects creates drama. The picture is organized into a backward C. It's a "read-in" kind of painting: the viewer's eye starts with the plate, moves up to the nectarines, then to the grapes, then the coffeepot, and finally ends at the bottle. Organizing the objects into a definite plan keeps the picture from looking like a random group of objects.

THE KITCHEN

Here's a wide value range. The rug on the floor is almost black, and the highlight on the stove is almost white. I painted this picture sitting in a corner of our kitchen: I started at the cereal bowl and worked back into the distance. With so complicated a subject this seemed the best way to keep all that material under control.

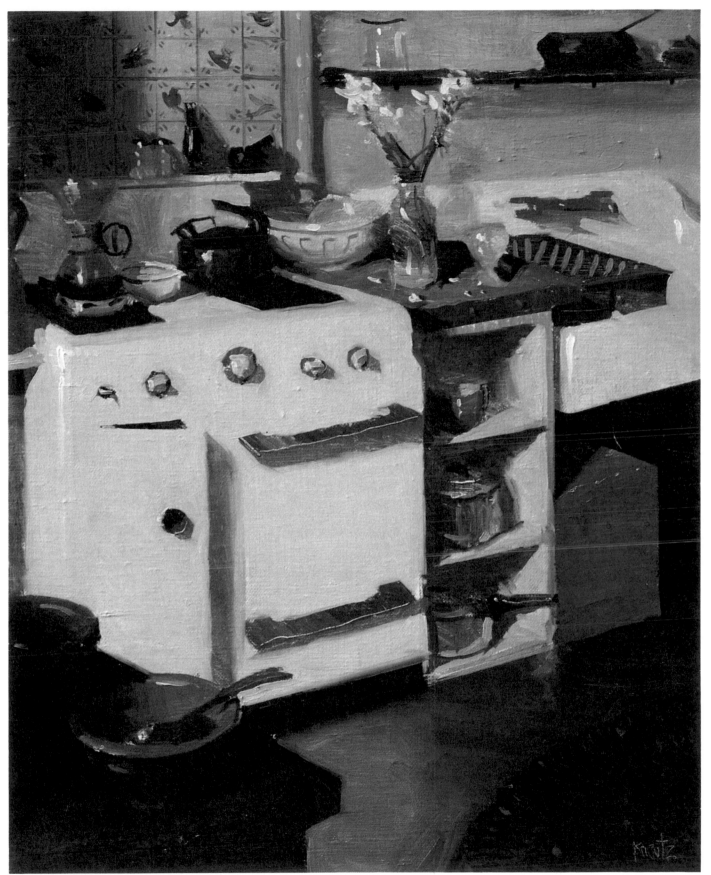

THE KITCHEN. 20″ × 16″ (50.8 × 40.6 cm). Private collection.

Could the Number of Values Be Reduced?

The visual world is composed of an infinity of values. Any single object contains a multitude of gradations from light to dark. For the artist painting that object to try and record each nuance would be as futile as it would be inartistic. Art is a synthesis, a condensation, not a documentation. The artist is reducing the external to its essence. A multitude of values exists, but the painter tries to select only the values that communicate the most and give the picture the most life.

A picture gains in impact when you reduce the number of its values. The fewer values the better. The still life on the top shows how too many value changes weaken the image. There are so many gradations that nothing reads as a simple statement. In the still life on the bottom, I reduced the values to about four, and consequently the background and the black pot are less obtrusive, and the silver vase and orange are more compelling.

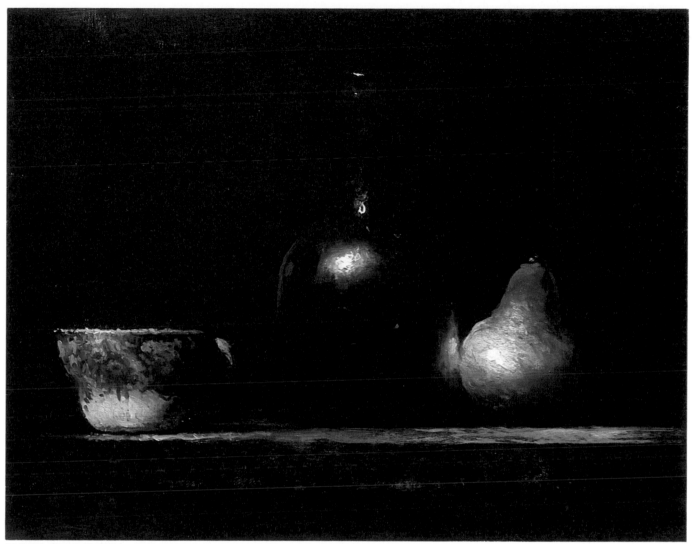

THREE ON A SHELF. 18″ × 24″ (45.7 × 61 cm). O'Brien's Art Emporium.

THREE ON A SHELF

This still life contains the fewest values possible in order to achieve a dramatic effect. The background and bottle are black, the cup is a middletone, the pear is a few notches higher on the gray scale, and the highlights are almost white—basically four values. It might be helpful to point out here that the values weren't this simple to begin with. I painted and repainted the bottle many times before I figured out that it worked out much better if it was the same value as the background. That seems generally to be the process: isolating things, defining their values, and eventually discovering that the picture looks stronger when the objects are integrated.

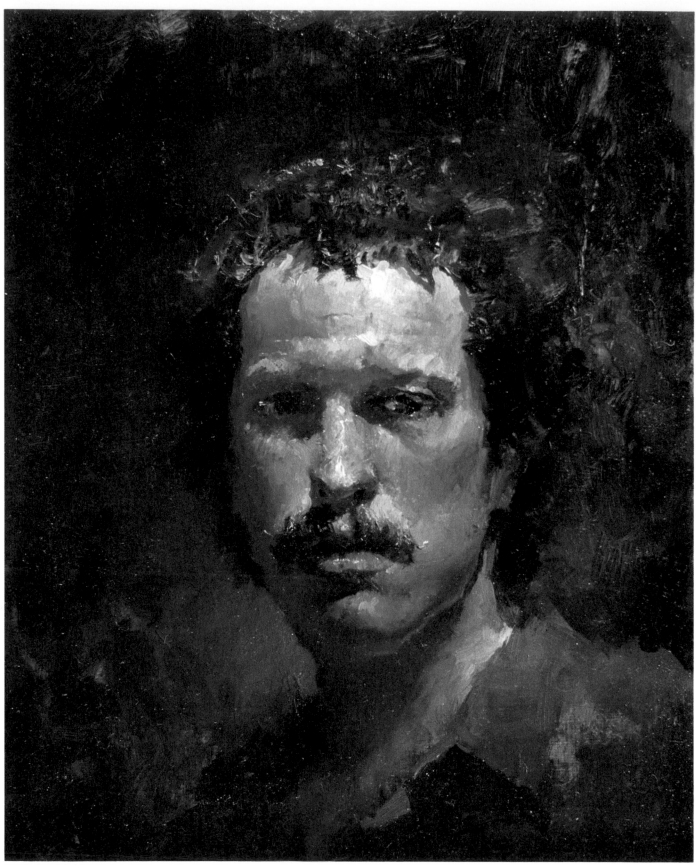

SELF-PORTRAIT. 10″ × 8″ (25.4 × 20.3 cm). Collection of Richard Weers.

LAST LIGHT. 15" × 17" (38.1 × 43.2 cm). Private collection.

SELF-PORTRAIT

The idea here was to make everything roughly the same value except the face. The hair, the background, and the shirt are pretty much the same value, and that draws attention to the focal point: the face. This is a functional way of using values. The viewer's eye is forced to look at the center of interest because it's the only part of the picture with any value differentiation; everything else is approximately the same dark gray value.

LAST LIGHT

Here's a study in close values. To capture the look of dusk, I kept all the earth-bound material fairly dark and made the sky as brilliant as I could. I made the flowers and vegetables, for example, the same value as the grass, and I made the trees the same value as the bushes. The buildings and the exposed earth are the same value. All together, they add up to only four values.

I actually ended up painting two versions of this scene. This was done on the spot, at sunset, and because the light was fading, I had to paint rapidly and go for a lively, short-handed effect. That's my mother-in-law, Louisana Owen, working away on her garden in the cool of the last light.

Part Four

Light

If a picture doesn't have light flowing through it, it looks weak. You can use pure color, splatter on the paint, outline everything in purple—but if you neglect the vibrancy of insightfully depicted light, the picture will only look superficially exciting. If you really analyze and communicate the way light flows across form, the picture will become resonant.

The thing to remember is that you're not really painting a green apple, you're painting light hitting an apple. The apple's existence is revealed to us by light. The artist has somehow to convert that light into strokes of paint. The apple has a color but the light has color too, and light both reveals the color of the apple and imposes its color *on* the apple. Cool north light, for example, creates a cool, pearly highlight on the green surface. If the apple is in sunlight, the highlight would be warmer, more yellow. To really get the look of the object, you must analyze the light on it. What direction is it coming from? What color is it? How bright is it? How much of the object's surface does it cover? All these questions have to be asked and answered. Such a procedure is hard, more like science than many people expect art to be. We like the idea of the artist almost sword-fighting with the canvas, making dynamic strokes that explode out of an inner vision. Staring at an apple for an hour to get a better sense of how the light is working seems a little low on romance. But all the great artists of the past must have put in their time staring at the apple. That's where a lot of their power resides. They figured out what was going on, and their paintings pass that distillation and analysis on to the viewer. The exciting brushwork and dazzling paint manipulation that many of them used (I'm thinking of Frans Hals or John Singer Sargent) are based on keen observation. To get a bravura look, you really have to discover explicitly how the light reveals the form. And that means concentration and analysis. The artist may be expressive, may even be sword-fighting slightly, but mainly he or she is figuring out how to turn the interaction of light and form into paint.

The questions that follow are questions to ask when the picture you're working on doesn't look as though it has light in it.

Is the Subject Effectively Lit?

For a painter's purpose, most indoor situations have too many light sources. Windows, lamps, doors, and so on, combine to create multiple highlights and shadows, and that makes form difficult to render convincingly. With a single light source, on the other hand, the object being painted can be reduced to three planes: the side facing the light is the *light plane,* the side at a slightly oblique angle is the *middletone plane,* and the side away from the light is the *shadow plane.* Having these three simple planes clearly delineated by the light makes it easier to paint the picture. Visually, it's powerful. Putting an additional light source on the subject confuses the structure. Light can no longer go through the light–darker–darkest progression; it gets interrupted by some other light going the other way.

A multiple light-source setup can be painted and it can look good, but to me it's not as powerful as a single strong light. Certain Rembrandt or Vermeer paintings are so vivid that you can close your eyes and see them clearly. The one factor of the light coming into the darkness and revealing the subject gives these pictures a strong imagistic quality. It communicates an intense, purposeful search for the significant. It reduces visual reality to its essence.

To me, the ideal painting situation is to block off all the lights except for one high window facing north. North light is good because it's constant. If the window is facing east, west, or south, at some point in the day sunlight comes into the room. That's usually not too good because it's not constant; it moves around the studio as the day progresses.

Putting one light source on the setup is just the beginning. You must still resolve the problem of how much of each form is in the light and how much in shadow.

The angle of the light is another important consideration. Whether it comes from below, the side, or above, you need to figure out how it moves across the form. Ask yourself if the top planes are brighter or darker than the side planes. If the subject is lit from above the top planes will be brighter; if the light comes from a lower angle, they'll be darker.

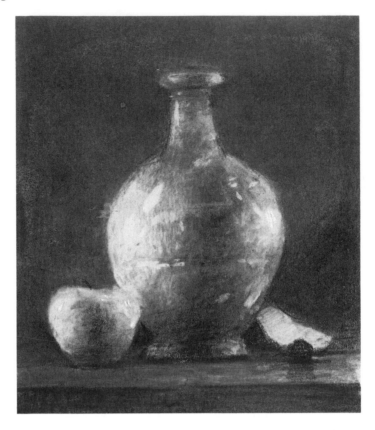

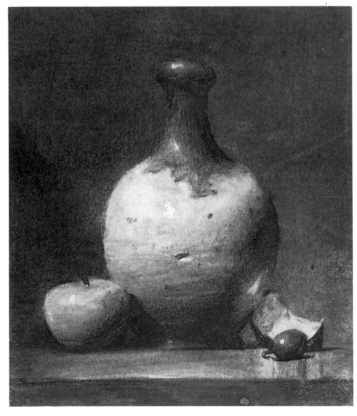

In the picture on the top, the light is coming from both sides of the setup, thus creating a slightly unsettling effect. The still life on the bottom is lit from only one side, and consequently the picture takes on a quieter look.

SUGAR POT

This picture has an ideal three-quarter light. The shape of the light pattern emphasizes the roundness of the pot, and the single-source, left-to-right direction of the light gives the image impact.

BAHIA MAR

In this painting, I'm looking into the light source. Everything facing me is in shadow. In this kind of situation, an umbrella, or at least a baseball cap, is mandatory for keeping the sun at bay. I stood here without either for hours, and by the end of the day I couldn't see much of anything anymore.

SUGAR POT. 10″ × 12″ (25.4 × 30.5 cm). Collection of Joanne Newbold.

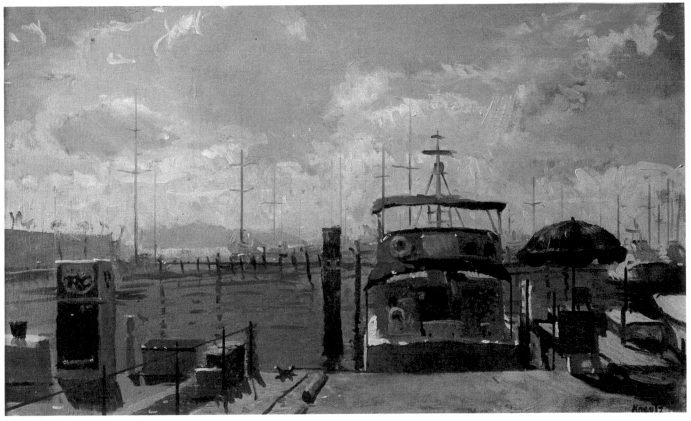

BAHIA MAR. 9″ × 12″ (22.9 × 30.5 cm). Collection of Andrew Ball.

ELLEN'S SHED. 10" × 14" (25.4 × 35.6 cm). Collection of Polly Porter.

ELLEN'S SHED

Here's another top-light situation. On an overcast day all the light comes from above. The top planes, the driveway and rooftops, are brightest because they're facing the light source. This throws the underplanes into deep shadow. Painting outdoors requires as much, if not more, sensitivity to light direction than painting indoors.

JAMES IN A YELLOW SHIRT. 35" × 24" (88.9 × 61 cm). Collection of Gina Kreutz.

JAMES IN A YELLOW SHIRT

This painting was set up to exploit the possibilities of strong top-lighting. I got James to sit directly under the skylight so that only the top planes are lit; everything else is thrown into dark halftone or shadow.

Is the Light Area Big Enough?

If everything in a picture leads up to a light focal point, this area must be large enough to make it effective, to make it worthwhile. All that mystery can't be justified if the center of interest is too small. For the murky area to work, the bright area has to have enough volume to hold the viewer's attention.

In the still life on the top the lights look a little isolated, and none of them is big enough to really command attention. In the still life on the bottom I put in the lighter water vase as a way to connect the flower to the onions, and I also put more light on the table-top. To me, the bigger light area makes the still life look more like a picture.

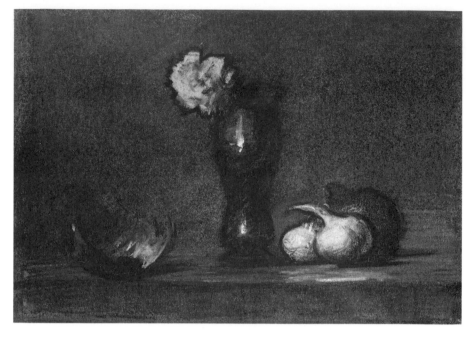

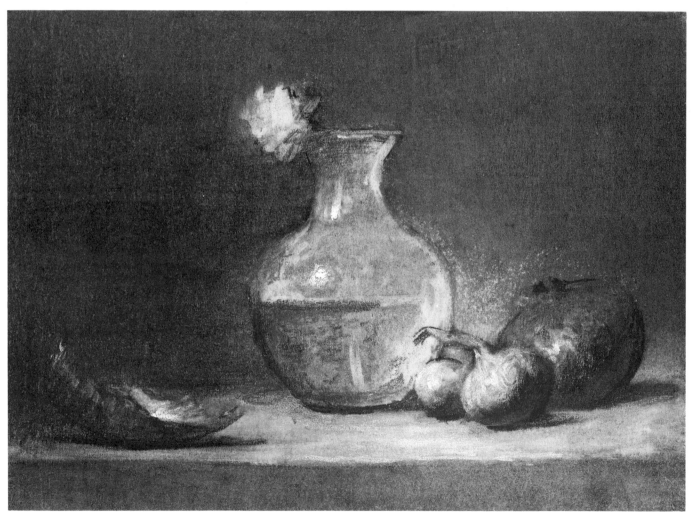

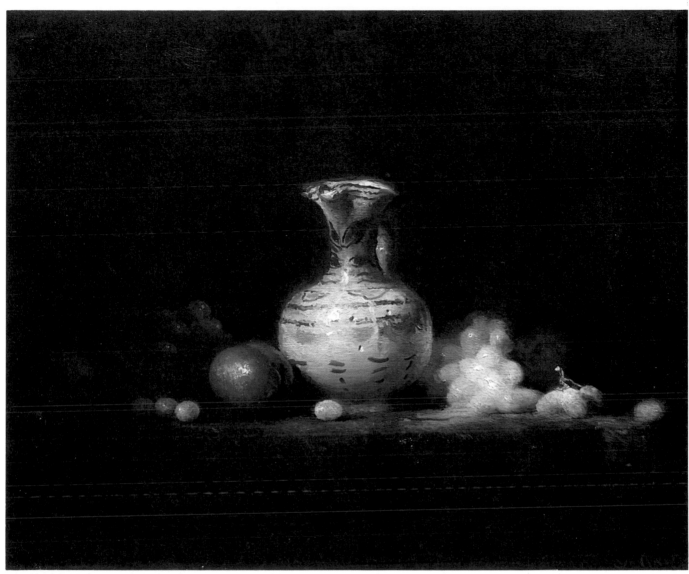

MEXICAN PITCHER. 18″ × 24″ (45.7 × 61 cm). Collection of Patrick and Carol Brady.

MEXICAN PITCHER

This painting was conceived from the outset as a study of massed light. I made the central light image as big and bright as possible. The grapes, especially, were pushed up the value scale so that they became part of the pitcher's aura.

VICTORIANA

Here again is a painting based on massed light. The model owned this Victorian dress, and it was so bright and dazzling that I decided to make it the big event of the picture. This kind of costume is so much fun to paint that it always makes me suspect that one of the reasons pre-1920s painting looks superior is because the apparel was so flattering, so full of character. It's a commonplace to say that the artist is supposed to reflect his times, but I don't think it's necessarily true. Reflecting the times is a journalist's function. I think the artist's obligation is to find universals. Rembrandt, after all, seems to have loved getting himself or his models dressed up in preposterous Oriental costumes that had nothing to do with seventeenth-century Amsterdam. Mozart's operas, Shakespeare's plays, Byron's poetry—all are artistic improvisations upon an imagined, exotic past.

MADELEINE

The model here had an unusual type of beauty, with a pale and somewhat broad face that drew my attention and seemed to demand a big light focus. I built the picture around this center of light and used a broad value range; her flesh color is in a very high key, and the background is almost black.

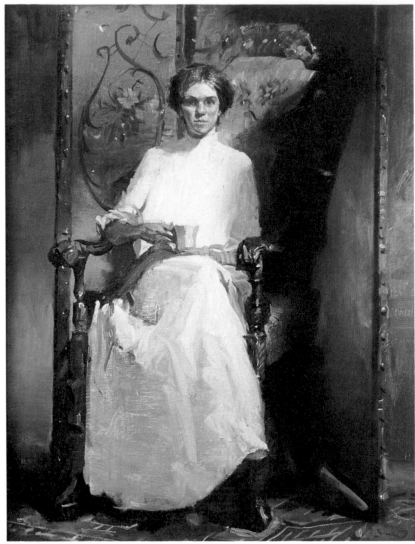

VICTORIANA. 30" × 20" (76.2 × 50.8 cm). Collection of Mr and Mrs. Robert Kinney.

LAKE COUNTRY

The sky and the lake are the light areas here, and making them cover this much of the picture creates a vista. Designing your landscape so that there is a lot of sky creates a grand effect. When land dominates the canvas, on the other hand, the picture can look more particular, more specific. Sky suggests universality.

LAKE COUNTRY.
20" × 25" (50.8 × 63.5 cm).
Collection of E. Brown and K. Kimball.

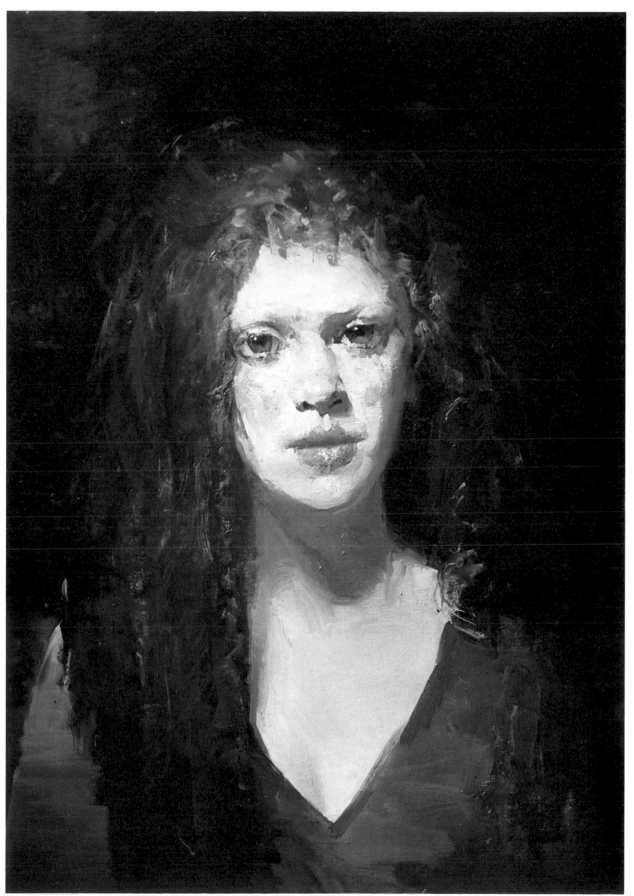

MADELEINE. 32″ × 24″ (81.2 × 61 cm). Private collection.

Would the Light Look Stronger with a Suggestion of Burnout?

How do we know when something is really bright? What cues us? Obviously, anything that is bright is high on the value scale, but there's another factor that's just as important, another way brightness reveals its intensity: anything that's brightly lit burns out whatever darks are near it. That halation is the true sign of strong light. When something is bright the area around it also gets bright. Keeping that in mind as you paint can help intensify the chiaroscuro and also help give a more atmospheric, air-filled look to your painting.

This way of depicting intense light is valuable for its own sake, but it's also useful because it gives you something to paint beyond the literal. Instead of painting a vase against a background, you're painting light hitting the vase, burning out its details, and shimmering into the atmosphere. You've got a subject to paint beyond the mundane content.

To help explain how this effect works I've rendered the still life on the top without any burnout. The white highlights sit on the surfaces without affecting the adjacent darks. In the still life on the bottom, I lightened the darks that surround the highlights and put some reflected light from the pear into the pot.

BIRCH TREE. 18″ × 25″ (45.7 × 63.5 cm). Private collection.

BIRCH TREE

The sun here is hanging a little way above the horizon, partly obscured by clouds. Using white with just a bit of yellow, I made that the brightest part of the canvas. The closer the clouds get to that area, the brighter they are. This kind of picture is more a sky painting than anything else. The ground area is mainly the place from which we view the drama above.

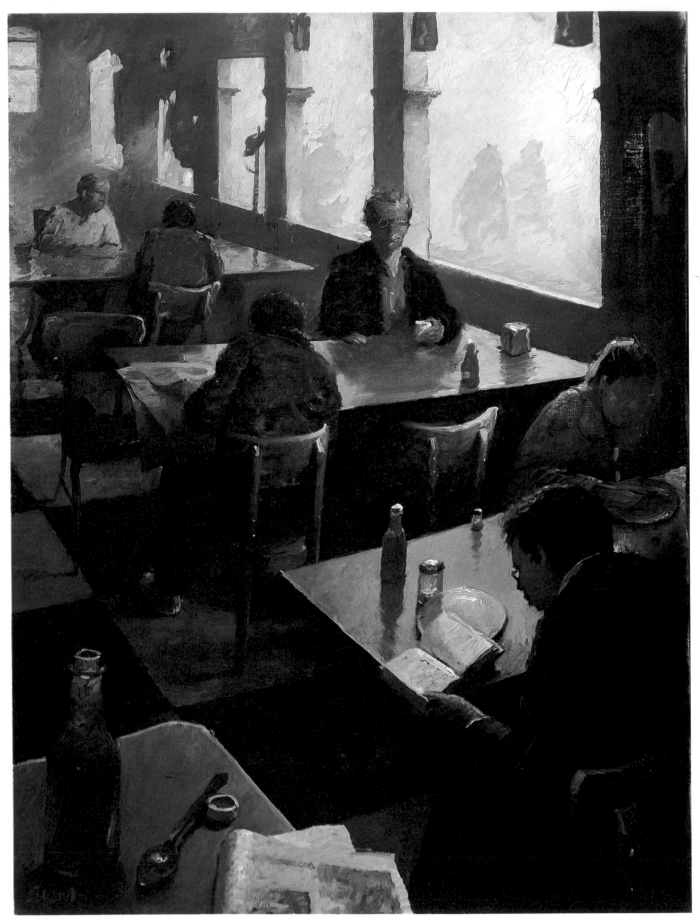

IN THE COFFEESHOP. 32″ × 24″ (81.2 × 61 cm). Collection of Frederick H. Miller.

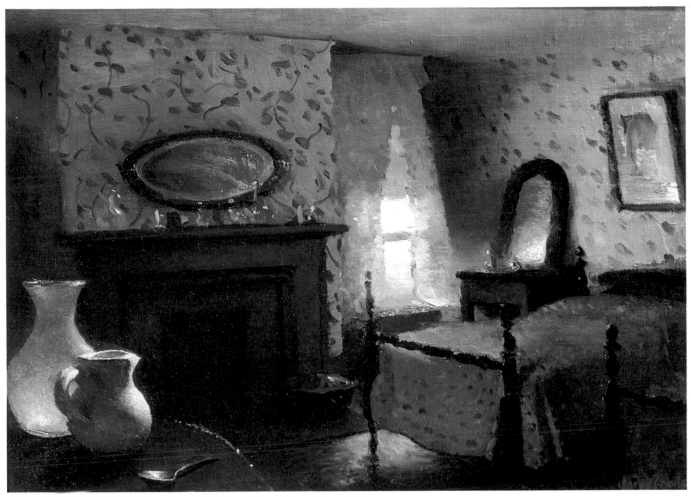

FARMHOUSE BEDROOM. 14" × 18" (35.6 × 45.7 cm). Fanny Garver Gallery

FARMHOUSE BEDROOM

The window here is the focal point as well as the light source. To make it look as light-filled as possible I lightened all the darks within and around it and painted a glowy haze into the surrounding atmosphere.

IN THE COFFEESHOP

The windows are the light source in this picture, and to convey their brightness I mixed two complements (Venetian red and cobalt blue) and added a lot of white. To make them look especially bright I put in some pedestrians that appear to be washed out by the light. Except for the ketchup bottle and newspaper, the whole painting was done from pencil sketches I did in the coffeeshop downstairs.

Do the Lights Have a Continuous Flow?

In representational painting, what's on the canvas is always a metaphor for reality. You're not really painting a nose, you're making a collection of visual signals that say "nose" to the viewer. You're not painting light, you're trying to find an equivalent in oil paint of the way light looks. The liquid nature of oil paint becomes a metaphor for the substance of light, and that metaphor is strengthened if, like a liquid, the light flows without interruption from the source. A raindrop trickling down a windowpane wouldn't come to a stop, disappear, and then reappear again farther down. It would flow in a continuous way. The flow might narrow in places, but it wouldn't disappear altogether. Light in a picture needs that same continuity.

In the still life on the top, each object is isolated from its neighbor, and there's not much sense of the light moving between them. In the still life on the bottom, I pushed the lights together and made sure that the light flowed continuously. The light starts at the glass, goes down to the bowl, goes across the two oranges right into the pot, and finally ends at the orange slice.

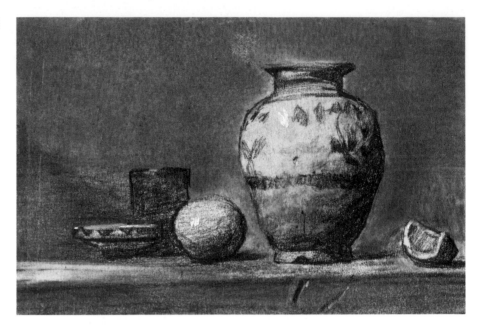

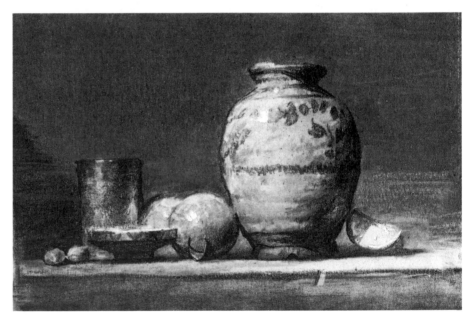

PURPLE AND WHITE CHRYSANTHEMUMS

The flow of the light starts with the white flowers at the upper left side of the bunch of flowers and rolls down toward the green vase, ending at the little daisylike flower sitting partly in shadow on the vase's front rim. Because most flowers don't last very long, it's best to move quickly and go after the general shape of the arrangement rather than get bogged down in detail. This painting was more a description of form that carried light than a rendering of specific flowers.

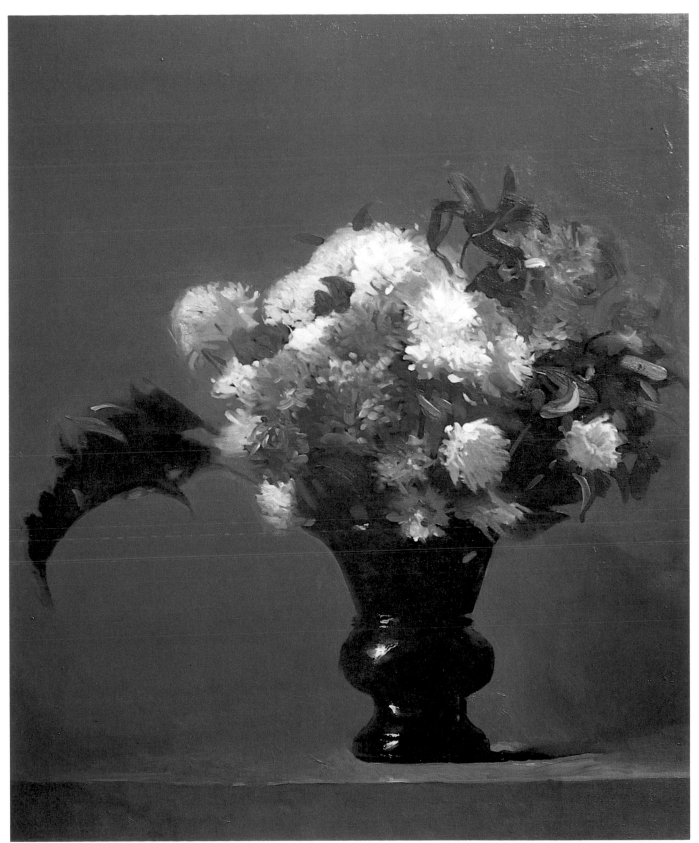

PURPLE AND WHITE CHRYSANTHEMUMS. 24″ × 18″ (61 × 45.7 cm). Collection of Dr. and Mrs. William Blockstein.

WALKING THE TRACKS

This was a tricky light setup. I was looking into the setting sun, and it was rimming the train and the water tower and the tracks and the trees. That sunlit outline provided a nice way to link up all the lights. I also used the smoke as a light bridge. Together, the lights form an elongated oval, with the bright clouds and bright tracks as its upper and lower boundaries.

DARK STUDIO

The flow of light here goes from the model's hair down her robed arms to her knees and then splits out in two directions, one side going to the pot and one going to the fan and chair. This picture was difficult because so much of the model was in shadow. The only way to describe what's going on in her upper body is through reflected light. The light shining up from her knees becomes the light source for her torso, making all the under-planes the brightest part of that shadow area.

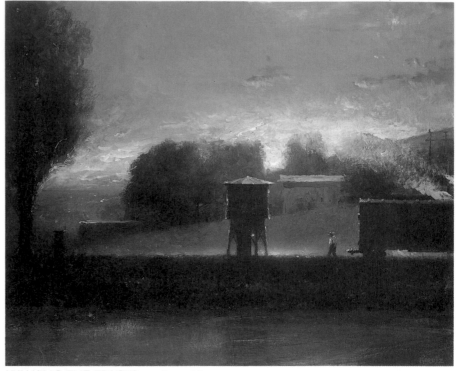

WALKING THE TRACKS. 18" × 24" (45.7 × 61 cm). O'Brien's Art Emporium.

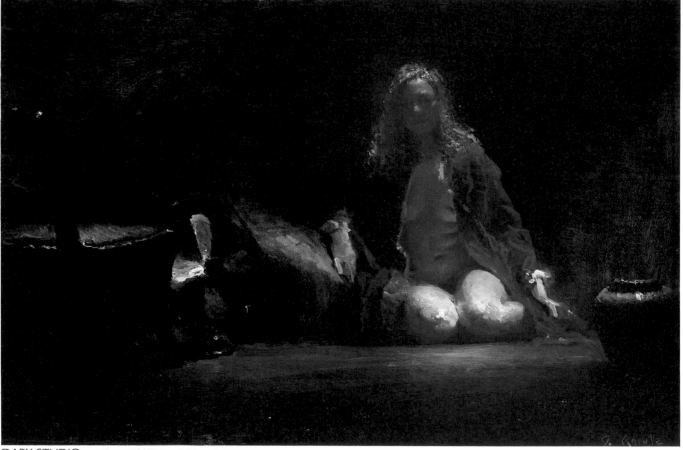

DARK STUDIO. 10" × 15" (25.4 × 38.1 cm). Private collection.

BLUE FISH. 24″ × 30″ (61 × 76.2 cm). Private collection.

BLUE FISH

Here the light flow is guided, as it were, along the back wall by the pieces of silk. In the foreground, I used the lemons as a way to lead the light to the fish.

This was my first and probably last attempt at painting a fish. The picture was big and complicated, so painting it stretched out over a week. By the fourth day I could barely stand to look at them. Needless to say, the smell gradually became unbelievable. I think the only sane way to paint fish would be to move with a lot of speed and get it done in one sitting.

Is the Light Gradated?

To keep a picture from looking static there must be a sense of the light increasing and decreasing in intensity throughout. The light area of each object must contain a lighter and a darker part, and the picture as a whole should have a sense of orchestration from either dark to light or light to dark. How you choose to orchestrate that flow is dictated by the dimensional and esthetic needs of the picture. For example, if you're painting a figure and you want the knee to come forward, you can make the light increase in intensity as it flows down the leg from the thigh, becoming brightest at the knee. Or if you want the figure as a whole to look more compelling, you can gradate the light in the background so that it becomes brightest around the figure.

In the still life on the top I painted in everything with one flat tone; the bottle, the pot, the lemon, the background, and the foreground are all reduced to a silhouette of one color. In the still life on the bottom I added a light-to-dark gradation to each of those areas. The pot, for example, goes from dark to light and back to dark again, with the brightest spot at the place nearest to us—the center of the pot. Because there's more orchestration of the dark and light in the lower picture it conveys more sense of drama.

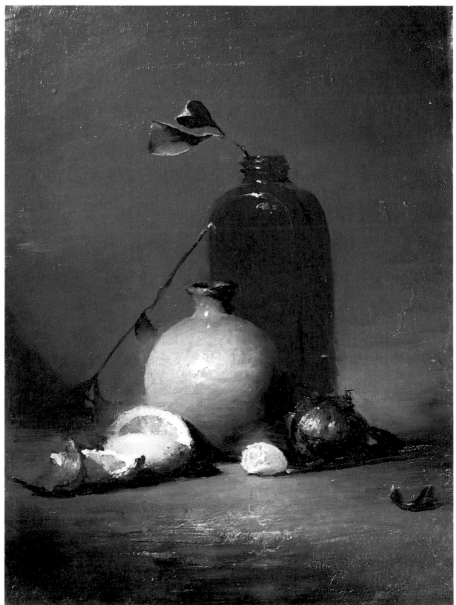

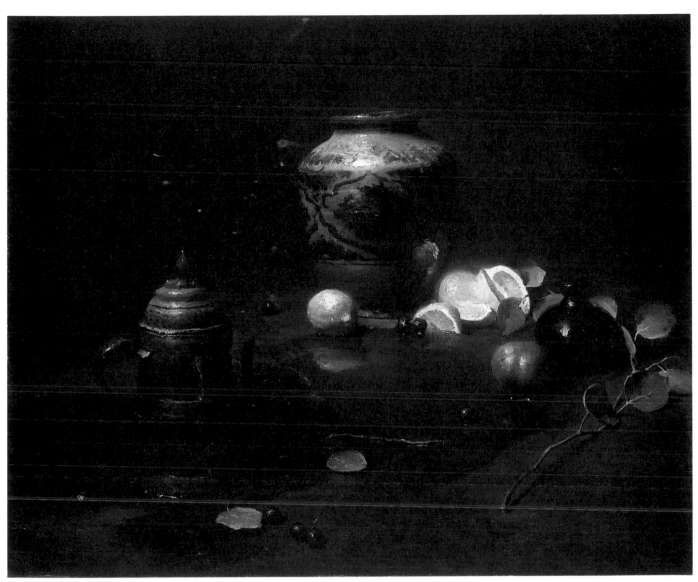

PERSIAN STILL LIFE. 25" × 30" (63.5 × 76.2 cm). Fanny Garver Gallery.

PERSIAN STILL LIFE

Here I organized the lighting so the viewer's eye is led into the picture from dark to light to the focal point—the lemons and pot. I set this still life up right under the skylight, and the top-lighting is evident in the brightening of all the top planes. The central pot, for instance, has the brightest color and value along its top lip. As dark as the background is, it too is orchestrated into a dark-to-light pattern that leads the eye to the focal point. I placed the objects so that they form an S-curve that leads the eye to the central image.

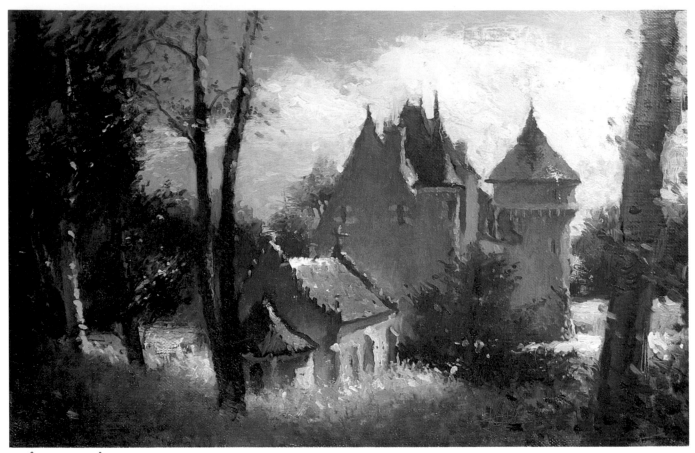

CHÂTEAU DE RÔCHE. 10″ × 15″ (25.4 × 38.1 cm). Fanny Garver Gallery.

CHÂTEAU DE RÔCHE

The sky in this painting shows what I mean by gradated light. This picture was painted with me looking almost directly into the sun, and the light was brightest on the righthand side of the canvas. For that area I used almost straight white, and the clouds and the blue of the sky gain in color and become lower in value the farther I move away from the area. My vantage point for this painting was a grove of trees behind the château; I had to take some artistic license with them, moving a few over and eliminating others, to get the composition I wanted.

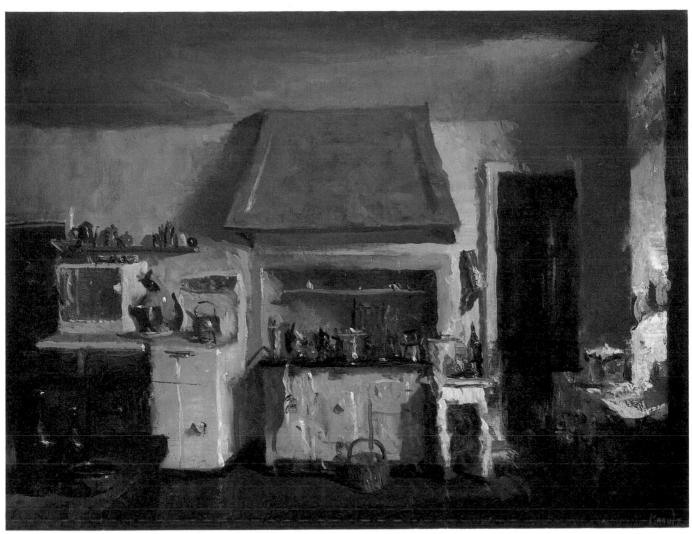

ELLEN'S KITCHEN. 18″ × 24″ (45.7 × 61 cm). Collection of Irving and Barbara Kreutz.

ELLEN'S KITCHEN

I used the ceiling here to communicate the way the light was flowing. It's at its brightest a little way from the window and then gradually tapers off as it moves across the room. I was working on top of an old canvas and I incorporated a lot of the rough earlier painting into this one. Most of the paint is thinly applied and the color underneath is bleeding through in places. This approach not only creates a more interesting surface but also makes the painting go easier because the painterly world is there at the very beginning; you don't have to build up to it. The only disadvantage is that you can miss some of the clarity you get with a clean canvas. It's sometimes hard to tell where you are.

Part Five

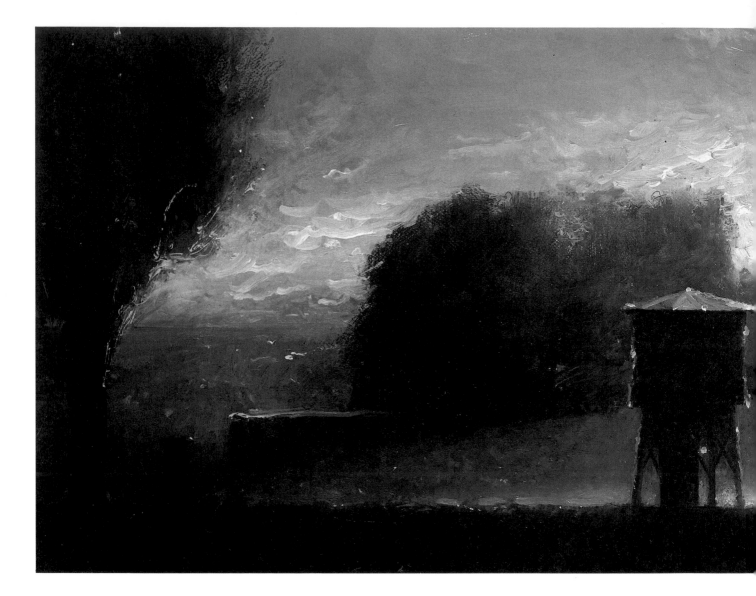

Shadows

Shadows, if done well, are never admired. They should be the last thing anyone looks at. And yet, in a way, they are the key to the painting. The color and value of the shadows set the tone for the whole picture. They tone down, obscure, parts of the painting, making other parts emerge more clearly.

It's been said that a good painting is always in danger of being ruined, that it takes two people to paint a picture: one to paint it, and one to take the brush away before it gets ruined. I don't think that's a real danger. If it's a really good picture it means that the artist is in control. When a painter is in the process of realizing an inner vision in a clear way, it's that clarity that gives the picture merit. If the choices a painter makes come from artistic insight, the painting won't be ruined because it is based on understanding, each step of the way, and if something must be altered or painted over again, the painter simply draws more deeply upon this understanding. A good painting is good not because it contains happy coincidences but because it communicates the conceptual thinking of the artist.

Shadows illustrate what I mean. Since shadow is such an elusive quarry, it's tempting to fake the color and hope nobody will notice. Instead of figuring out exactly what shadow color would create the desired effect for the picture, suppose you mixed up some scrubby dark gray and hoped that it would be anonymous enough not to cause any trouble, and that, while it didn't look too bad, it had a dullness to it that annoyed you. This is a familiar problem: what you've done looks alright but you're not quite satisfied with it. Should you risk "ruining" it? I think the answer is almost always "yes." If you were to start experimenting with this gray color, and then try and mix up some other colors (which didn't look too good either), and then if finally you decided the original wasn't all that bad but then couldn't re-create even *that*, it could be said that you had ruined the picture. But all that you've really done in this case is make public a private problem. That is to say, you've removed the thing that was concealing the still-unanswered question: "What is the shadow color?" To learn how to answer that question, you have to be willing to jeopardize the vaguely satisfactory parts of the painting. You *can* find the right shadow color eventually, or the right background color, or the right anything. It all depends on whether you believe a solution exists and are willing to risk what you've created up until that point in order to find it.

Shadows are often the focus of this dilemma because they so frequently need to be revised as the painting progresses. What looked satisfactory at the beginning can look weaker as the lights get brighter. I find I'm constantly fiddling with the shadows and checking out how each change affects the painting as a whole.

Do the Shadow Shapes Describe the Form?

Shadows are the foundation of the picture. They are what hold the light together. The shape of the shadow should echo the shape of the object. Rather than copy what the shadow looks like, the painter should use it to reinforce the overall shape of the object.

In the excitement of having your easel set up in front of the real thing—a person, a landscape, a still life—it's easy to lose sight of the pictorial requirements. You can get a panicky feeling that keeps you from describing things economically. The fear that your picture won't look real makes you want to copy everything slavishly and to disregard the bigger statement that will make what's on your canvas more true. When details and arbitrary optical effects take over, the results look flat, busy, and unconvincing. Shadows are particularly vulnerable. When the picture doesn't look real, shadows are the first to be blamed and they are promptly filled up with unnecessary (and unshadowlike) detail. The simpler the shadows are, the better, and they work best when they are an echo of the object or person they are part of.

In the still life on the top, the shadow shapes are arbitrary. They don't effectively describe the direction of the light or the shapes of the objects. In the still life on the bottom, they communicate better. The crescent shapes of the teapot and lemon shadows reinforce the idea of the objects' roundness. And the cast shadow on the wall behind describes the direction of the light.

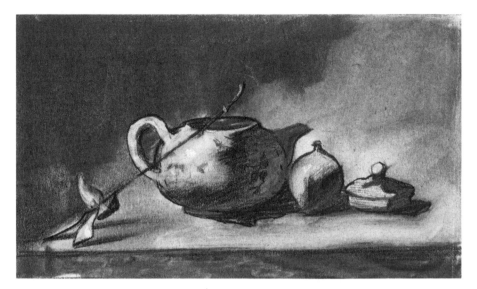

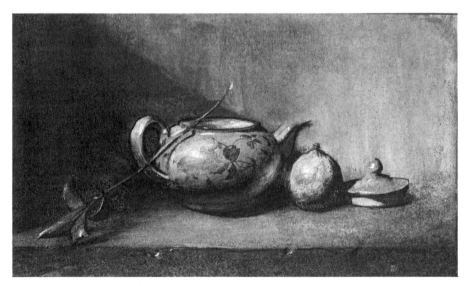

SELF-PORTRAIT

More of the face is in shadow than is in light here, with the side planes lit and the front planes not. I set it up that way on purpose to give the picture a mysterious look and to present the pictorial problem of describing the juncture where the shadow meets the light. I tried to use the shadow/light interplay at this point to convey the shape of the cheekbone and eye socket, in other words, to use the shadow shapes to describe the major planes of the face.

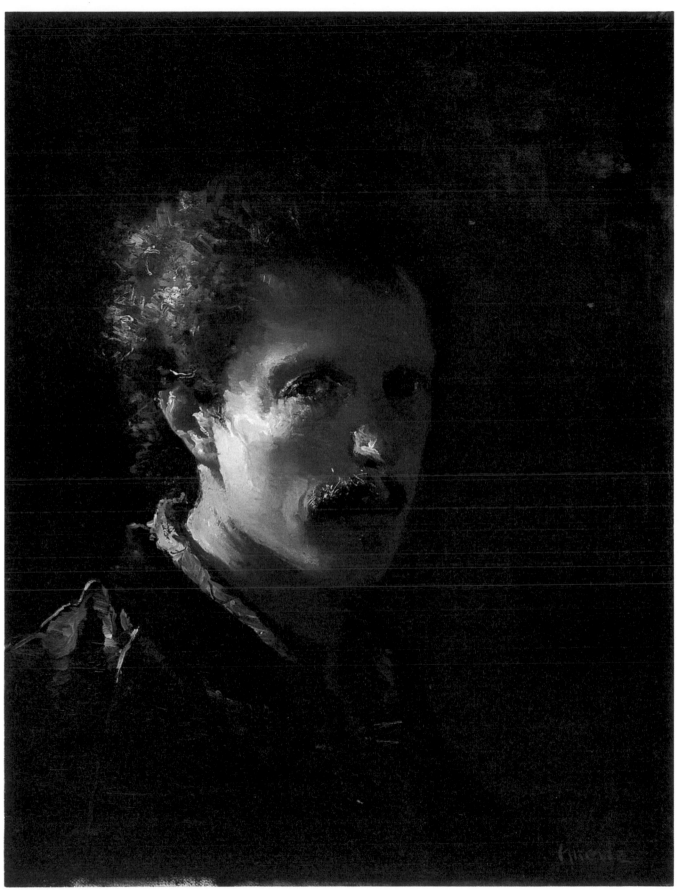

SELF-PORTRAIT. 20″ × 16″ (50.8 × 40.6 cm). Private collection.

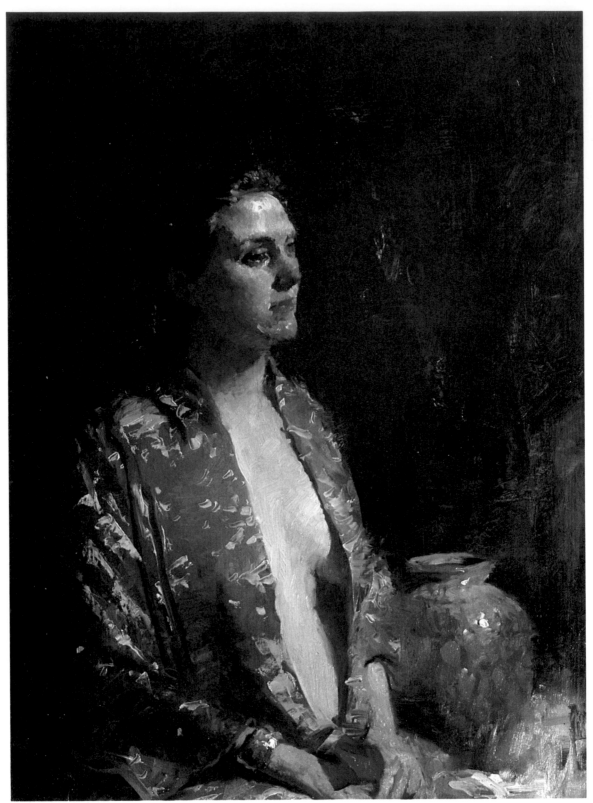

GREEN KIMONO. 16″ × 12″ (40.6 × 30.5 cm). Collection of Burdett and Michel Loomis.

GREEN KIMONO

The shadow on the head is shaped so that it echoes the head's general structure, beginning where the front plane becomes the side plane. This picture also illustrates a way to suggest detail without laboriously putting it in: the intricate pattern on the kimono was suggested by dashing in some vague strokes with the palette knife.

Are the Shadows Warm Enough?

How do you paint shadows? The key is to figure out what distinguishes shadow from light. Shadows aren't just dark versions of what's in the light. They have a recognizable quality of their own that's different. They're *mysterious*. Our eyes naturally focus on the light and consequently render the content of the shadows less coherent. For the light to look crisp and luminous, the shadow must be vague and evocative, and if that's the quality we're after, the picture is easier to paint because a quality or an effect is more paintable than a thing.

The general feeling of mystery that all shadows have is best depicted with warm, dark colors. Warm tones suggest shadowy depth. Cool tones suggest light. There are complications, however, because of air. While the general tone of a dark interior is warm, the air is also being illuminated, and therefore cooled, so as things go back into depth, there's more and more lighted air in front of them, rendering them cooler. The shadows represent, if you will, the unilluminated parts of the environment; therefore they are warm. But to the extent that they are in the distance, or to the extent that they have light reflected onto them, they get cooler.

In other words, it's always a tricky balance. For the shadows to convey richness and mystery, they need to be warm. But for them to look airy, they need to be somewhat cool.

Outdoors, on a bright day, because there's so much light, everything is cooler. It's still a good idea, though, to treat the shadows as basically warm entities. This runs a little against the grain of accepted wisdom; I was told in my youth that outdoor shadows are cool. If it's not too subtle a distinction, I would say that their basic nature outdoors is warm but that they have a lot of cool light reflected into them. A car, for example, out in the sunlight would cast a warm shadow directly under it, but where the shadow extends away from the car it gets cooler because it reflects the color of the sky.

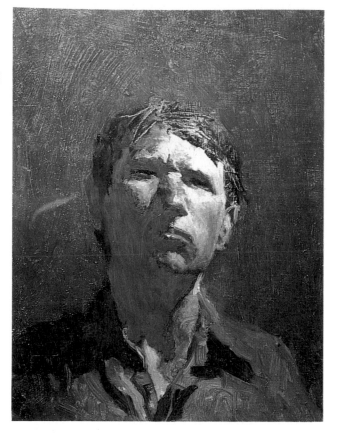

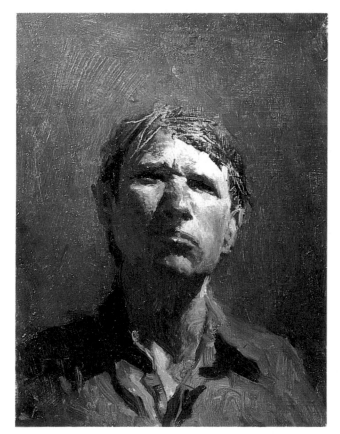

I used a cool, grayish tone for the shadow color in the face above, and while it doesn't look unnatural, it seems dull when compared with the warmer tone I used in the face below. The warmer shadow creates a richer look and that gives a greater feeling of depth. It also makes the light look more vibrant because its warmth contrasts with the light's coolness.

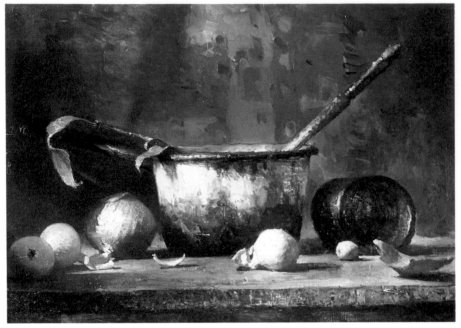

OIL POT. 13" × 18" (33.1 × 45.7 cm). Collection of Jim and Barbara Arnesen.

OIL POT

Here's the pot I use to make my oil medium. The tonal world is strictly one of cool lights and warm shadows. Notice that the pot in the light is painted with bright, thick paint. In the pot's shadow, the paint is thin and warm.

HOT-DOG MAN

This is an outdoor picture, painted on the spot with relatively warm shadows. I could have put more blue into them and gotten away with it, but I like the richer look that the brownish shadows give.

These umbrellaed hot-dog sellers provide a colorful, lively, and very human focus for a cityscape, and I'm tempted to sneak them into all my city pictures. There's something so paintable about the stripes on the umbrella and the shiny metal of the wagon.

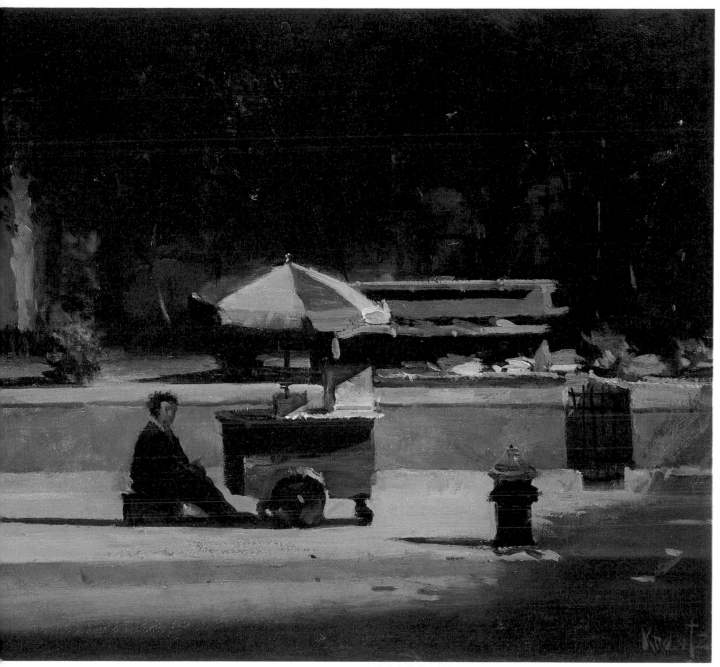

HOT-DOG MAN. 12″ × 20″ (30.5 × 50.8 cm). Collection of David Leffel.

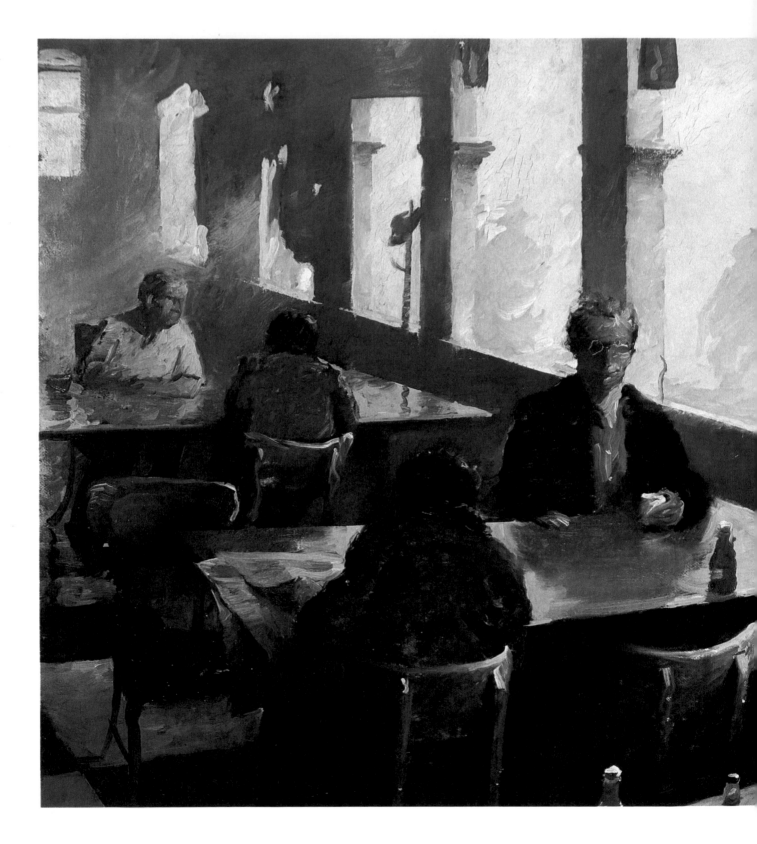

Depth

The biggest difference between twentieth-century painting and the painting that preceded it is depth: modern painting isn't concerned with it. Modern painting is about flatness; it explores possibilities of a flat canvas. Klee, Picasso, Mondrian, Pollock, Motherwell, all of them, to a greater or lesser extent, champion the two-dimensional surface. The "integrity of the picture plane" is what they are exploring. Even the new realism that's emerged over the last fifteen years doesn't violate that flat sensibility. The new realist paintings, for the most part, are derived from, and look like, photographs. The viewer's reaction isn't, "Doesn't that look real!" but, "Doesn't that look like a photograph!" Flatness is preserved.

Why a whole culture should have renounced such a rich tradition as chiaroscuro painting is a big puzzlement. But the renunciation was almost total, and from the 1920s onward it's hard to find any serious painter "painting" (in the sense in which the word had previously been used). Depicting light and depth became something like gun-blueing or powdered-wig-making, a lost art. If all of a sudden nobody knew or cared to know how to play the violin, you'd think it would be perceived as a cultural loss, that civilization would be understood to have dropped back a notch. But not many people reacted that way when representational painting fell from sight.

I bring this up because all this flatness that we've been studying and admiring for the last eighty years has made depicting depth increasingly difficult. And the endless celebration of flatness can be a stumbling block for the art student trying to learn to paint depth. At some point the student is forced to choose: if you want to master spatial painting, then in effect you need to decide that spatial painting is the worthier approach. You need to look at good realistic paintings and drawings and figure out how their creators got some things to go back and others to come forward; how air was depicted; how a figure was made to look like it existed in space; how a face's far side was made to look like it was turning away. Eventually, as you paint, you'll start thinking of your descriptions largely in terms of depth. It becomes not an element that's added on to the subject, but the subject itself.

Would the Addition of Foreground Material Deepen the Space?

Adding foreground material is an option that can help involve the viewer more strongly in the picture. It places the viewer in a context, identifying the spot from which the subject is being viewed. By showing the nearby objects to be much bigger than the rest of the material, you can magnify the depth of field. Make sure, though, that the foreground material covers enough area to make the visual point. Think of your composition in terms of balance, and if you're constructing a foreground/background setup, be sure that the foreground has enough weight. I like to exaggerate the size of this closeup component. It dramatizes the composition.

It's a good idea to think of your picture as a space, an environment rather than a collection of things. Make your canvas a stage set on which the visual drama occurs. Instead of painting, say, a nude, paint an area with a nude in it. If it does nothing else, this kind of thinking prevents the figure from getting so big on the canvas that parts of it are lost. If you're fitting the figure into an environment instead of onto a canvas, it's not such a tight squeeze.

Foreground material, then, is not put in simply because it happens to be there or because there's a big empty space at the bottom of the canvas. It's painted in because it creates the kind of spatial, dramatic effect that you want for your picture.

The picture on the top seemed somehow lacking, and without beginning. So I added the tabletop and props. I also emphasized the single light source of the window. The hard part was painting the pitcher and the glass bottle at such a tricky angle to the light.

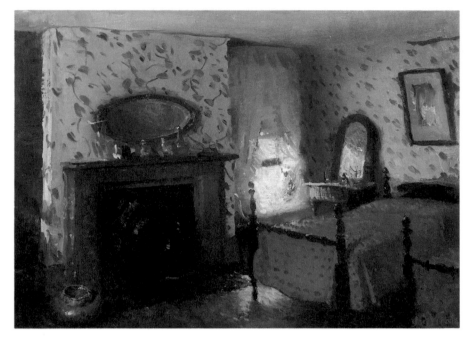

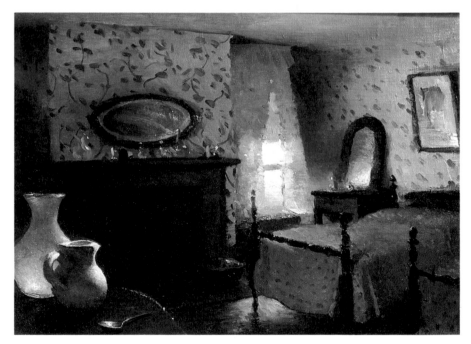

DEVIL'S RIVER FROM ABOVE

The palo verde bush helps increase the sense of space here. It provides a scale to the picture. I painted this out in the broiling sun of southwest Texas and my biggest problem was fighting off the huge flying insects that kept jumping out from behind my easel.

DEVIL'S RIVER FROM ABOVE. 10″ × 14″ (25.4 × 35.6 cm). O'Brien's Art Emporium.

CLOSED ON SUNDAYS

To paint this picture, I had to stand in a hallway that had a window that opened on to the interior of the coffeeshop. The ketchup bottle was right there, providing a natural anchor for the view.

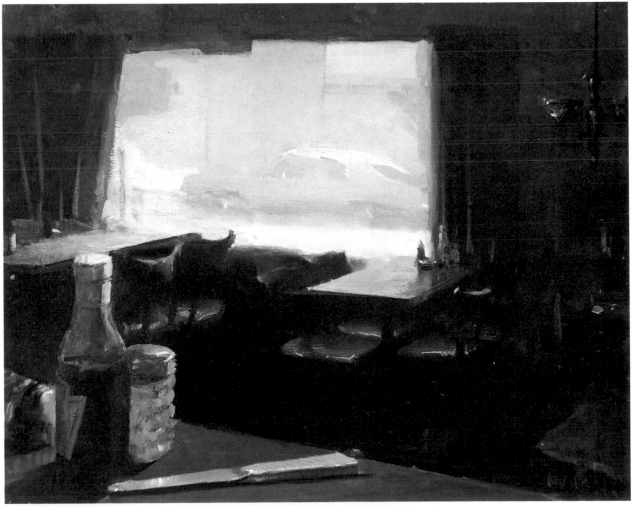

CLOSED ON SUNDAYS. 18″ × 24″ (45.7 × 61 cm). Collection of James M. Dennis.

Does the Background Recede Far Enough?

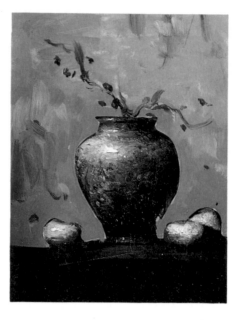

What tells us that one thing is nearer than another thing? Obviously things get smaller as they recede, but that's just part of what happens. Things in the distance have *less:* less color, less visible texture, less darkness, less brightness, and so on. As you paint you can use this diminishment to express depth. A thick piece of paint looks nearer than a thin one, a rich color looks nearer than a dull one, a deep dark looks nearer than a middle-tone, a hot color looks nearer than a cool one, a sharp edge looks nearer than a soft edge. Look at what you're doing in terms of the depth being expressed. Each stroke should make a statement about where it exists in the depth of field you're creating on your canvas.

Whatever you're painting, there needs to be a background color. In a landscape, that color is the far sky color. In a portrait or still life, that color can be seen as the color of the shadowy air. In both cases, once that color is set, all the things in the picture can be spatially placed according to how much of that background color they have in them. In a landscape, the distant hills or mountains can be made to look far away by painting them with just a slightly darker version of the sky color. In a still life or portrait, things look nearer or farther away according to how much of the shadowy air color they have.

A background color should be warm enough to have depth, but cool enough to be airy. It also must fit into the color world of the setup. If it doesn't belong, it won't go back into the background. There's a sense in which the background color is a composite of all the colors in the picture. It unifies all the different colors.

In the still life on the top, I painted in a background color that I don't think looks right; it's too green to really go back and it clashes with the foreground material. I tried a subtler one in the still life on the bottom, using a dark blue-gray color as a way to relate all the color elements.

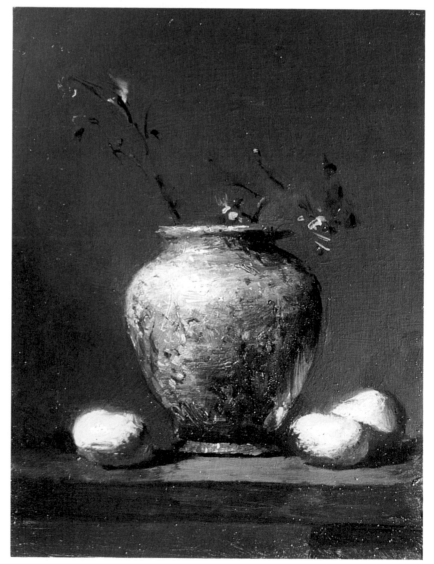

ROCKS AND WAVES, NARRAGANSETT BAY. 10" × 15" (25.4 × 38.1 cm). Private collection.

ROCKS AND WAVES, NARRAGANSETT BAY

The background color here is the distant sky color, a lavender blue. As things go back toward it they take on more of that color. The shadows, especially, are rich in the foreground (black mixed with Venetian red), but as they go back they get bluer.

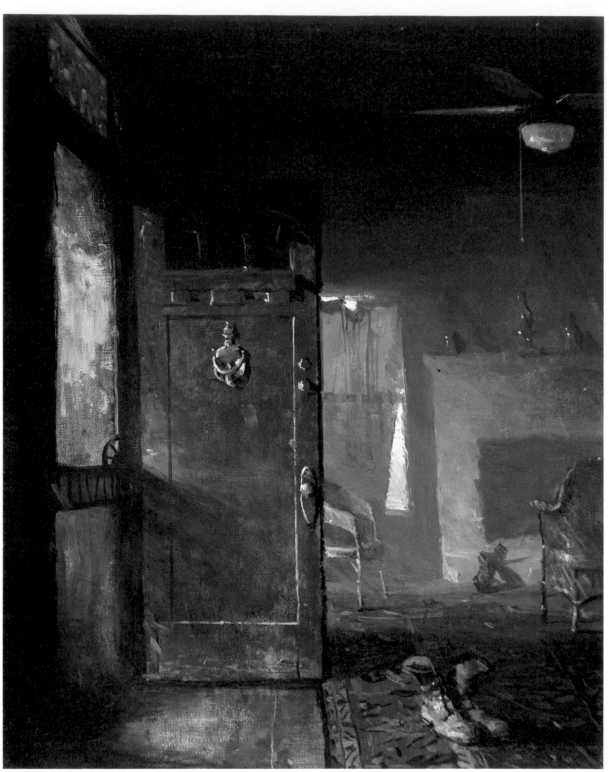

BOOTS ON THE RUG. 20" × 16" (50.8 × 40.6 cm). Collection of James and Betty McDonald.

BOOTS ON THE RUG

Getting the area behind the door to go back was one of the big problems I had with this picture. The more things I put in, the more it came forward. I finally got rid of the dark darks that were there, and then it started to work: the darks come forward. The farther back a thing is, the more air there is between us and it. It gets lighter because the light in the air forms a semi-opaque barrier. This effect is obvious when we look at a distant mountain, but it's just as true when we look across the room. Getting the background to recede in this painting wasn't important for its own sake, but because I wanted the main focus to be on the boots.

Are the Halftones Properly Related to the Background?

If you try to think always in terms of background and foreground, the halftones become less of a problem. Halftones are areas in the light, but because they are at a slight angle to it or are in a depression, they are not as bright as the other light areas. How do you paint dark light? A better question is, what color can you use to make the halftone area turn toward the background? The answer is easy: background color. Since the halftones are turning toward the background, they should partake of the background color. Operating in this way gets your thinking on the right path. You're not trying to duplicate the color you see; you're trying to find a logical color structure that will communicate dimensionality.

One of the most common uses of halftone is in the painting of flesh, which is a particularly elusive material to capture. There are many different hues from person to person, and within each individual there are also many color changes. All these nuances are hard enough to capture on their own, but add to them the problem of what color the halftone should be and things can seem overwhelming. That's why it's important to find some logical structure that will coordinate all that information. Putting background color into the areas that are turning toward the background is one way to simplify the complexity.

In this picture of my sister Charlotte, the background color—a mixture of raw umber, yellow ochre, and cobalt blue—was used as a way to get the jaw and cheek area to turn away from the viewer. My flesh color was Venetian red and Naples yellow, and wherever I wanted a turn, I mixed in some of my background color.

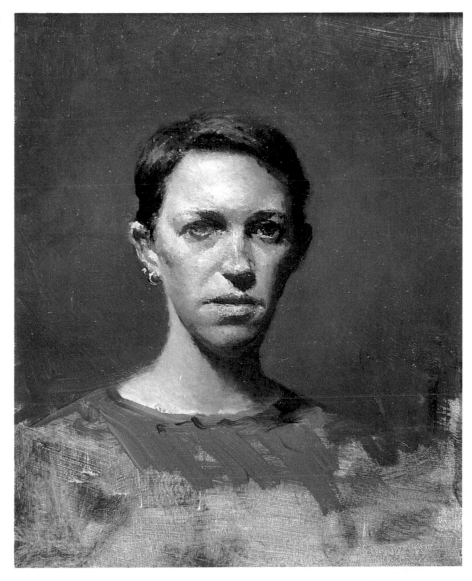

BELINDA. 16″ × 12″ (40.6 × 30.5 cm). Fanny Garver Gallery.

LANDLOCKED. 10″ × 15″ (25.4 × 38.1 cm). Private collection.

BELINDA

Because the background has purple in it, I used a purplish color to make the turning planes go back. The model here came for only one session, which usually isn't long enough for me, but in this case I liked the slightly unfinished look that resulted.

LANDLOCKED

Halftones are usually thought of in terms of flesh tones, that is, of people being painted in a studio. But their equivalent happens outdoors, too. In this example, the background color is green, so the halftones (the part of the light on the boat that's turning toward the shadow) get greener as they start to turn. The hardest part of painting this picture was getting the background trees to look like trees without putting in so much specific detail that they wouldn't stay back.

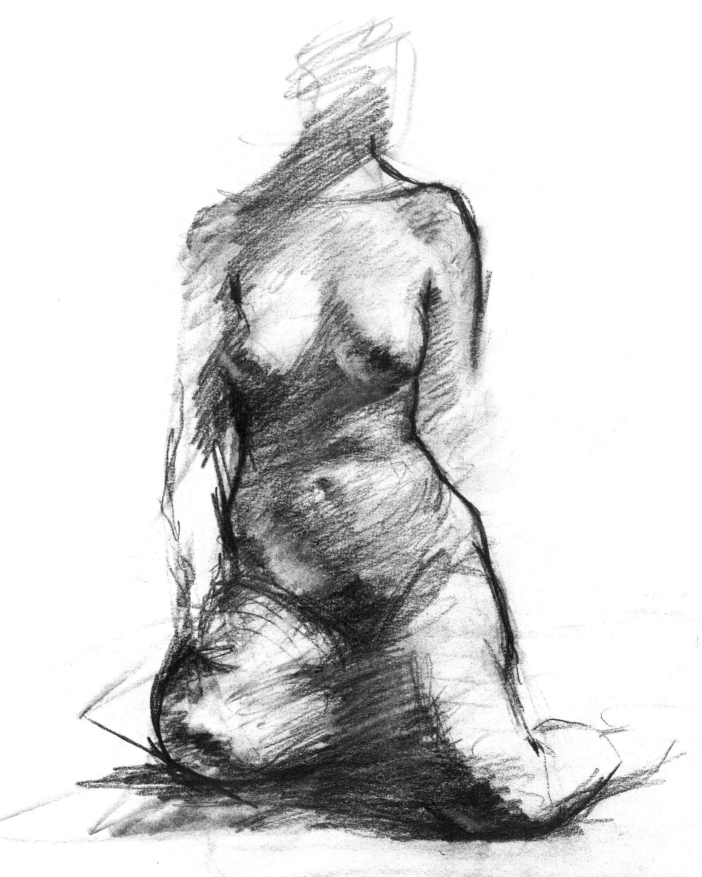

Solidity

We take for granted the solidity of form that exists all around us, but it can be difficult to get that quality onto the canvas. The difference between a picture copied from a photograph and one copied from life is often a question of gravity. Things in a painting copied from a photograph don't look like they have any weight. They can look "real" (as real as a photograph), but they usually don't look heavy. The reason is, when you copy a photograph your goal (consciously or unconsciously) becomes making the painting match the photo.

When you're painting from life you're trying to capture the qualities of external reality. *You,* not the camera, have to make the transition from the three-dimensional world to the two-dimensional surface. *You* have to make that transfer convincing. If you're copying from photographs, the translation has already occurred. You're just transforming a picture made with dyes and emulsion into one made with paint and oil. When you do the dimensional translation from reality to paint, an abstract leap occurs that is absent from mere copying. That easiness of copying from photographs can be tempting; it can also limit the painter to the concerns of photography rather than painting. The perspective dictated by the focal length of the lens, the light-to-dark range of the film, the ability of the lens to resolve detail, all legitimate concerns of photography, are alien to painting.

When you work from life, on the other hand, because of the immensity of information and because of your limited means (paint, brushes, and canvas), you're forced to make simplifications and generalities that lead to a painterly synthesis.

This reduction makes things look like they have weight because it emphasizes the underlying structure instead of the surface details. The weight that we sense a person has isn't only communicated by wrinkles or bulges but also by the subtle indications of the coherent unifying internal machine that, with the external features, makes a whole gravity-bound person. The artist's job is to find ways to show the interaction of the internal and external, to inform the surface with a solid structural underpinning.

Is the Underlying Form Being Communicated?

In painting and in drawing, you must be attentive to and describe the reality under the surface, the substructure upon which the surface details appear. Getting a feel for that underlying structure can be difficult. The eyes, the nose, the mouth—these are the things we notice right away, but if we paint them in without first analyzing what is supporting them, they'll look as if they're floating, with nothing to anchor them in their proper places.

This whole concept used to bother me when I was a student because *I* couldn't see the skull under the skin. I half-suspected that those who claimed to do so were bluffing. At some point, though, I figured out that what you're looking for is *evidence* of the skull, not the skull itself. If you look at a face and instead of accepting all its protrusions and grooves as mere facts try to analyze what's causing them, the problem of finding the underlying structure is more solvable. The flesh is taut against the bone in some places, sagging in others. Why? The face has a front plane and a side plane. Where do they meet? Is the brow ridge thick and bony, or soft and smooth? Are the cheekbones prominent or subtly defined? Some people's skulls are less in evidence than others, but if you're looking, and asking the right kind of questions, you can always find the causal foundation underneath. I've been speaking only of the head here, but obviously the idea holds for everything. All objects have some internal form that dictates their external appearance.

A good way to get into the kind of analysis I'm talking about is to paint self-portraits. There's something about having that free model there that lets you get involved. You can really peer at and, if need be, feel the area in question. You have the luxury of spending weeks trying to get the forehead just right, and that effort will pay off on all foreheads from then on. Also, there's an inherent power in the very nature of a self-portrait; there's something about a picture of a person painting the picture that's loaded with meaning and resonance. It's a situation where form and content are one.

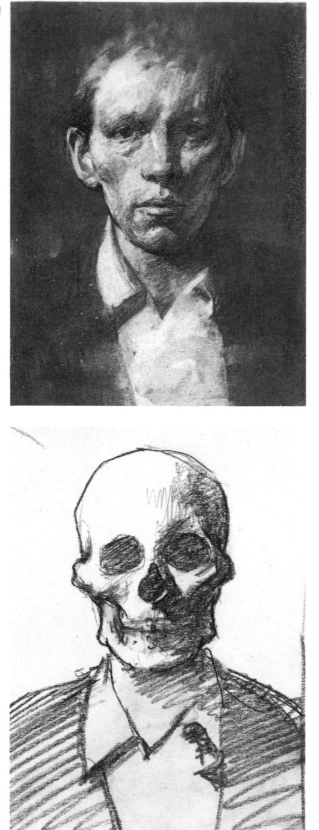

I modeled this head with an emphasis on the underlying structure. The model's physiognomy lent itself to that kind of treatment and I had no trouble finding the skull beneath the skin. In the drawing below, I've shown the skull under the same lighting conditions.

Demonstration: Communicating the Underlying Form

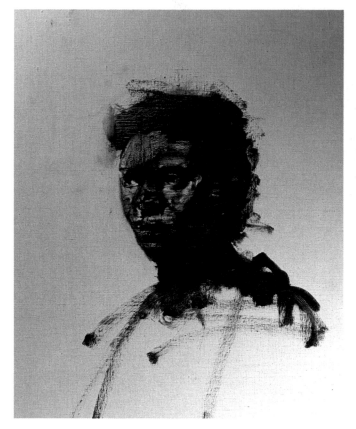 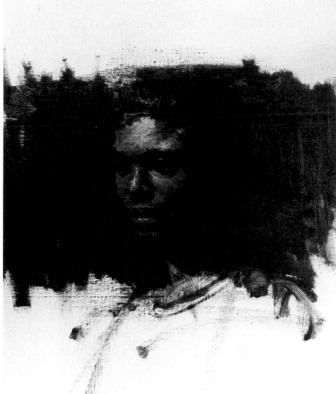

Step One. I start out with a rough, massed description of Gail's head. I'm after the general shape and structure of her front planes and side planes. No big commitment here, but I do want a fairly coherent description of the basic planes.

Step Two. Now I'm concentrating more on value, trying to figure out how mysteriously I want to play it. For the silver highlight to really shine out I have to keep the other values low.

Step Three. I brought up Gail's face color a little so the picture wouldn't be too gloomy. The color idea is clearer now— blue and orange.

GAIL.
20" × 18" (50.8 × 45.7 cm).
Private collection.

STUDIO NUDE

The thinness of the model made it easy to find and depict her underlying structure. Capturing the quality of her pose was the main task. She's putting most of her weight on her right hip but is also leaning against the sink behind her. I started this picture with a rough, generalized description of the gesture and then worked into it in a more refined way, beginning with the shoulders and working down.

THE ACROBAT

The lighting describes the form pretty clearly here: the side planes are lit, and the front planes are in dark halftone or shadow. I painted this picture quickly (for me) in just two sittings. Once I had set the model up in this lighting I could visualize how the picture was going to look. Also, I was working on an old scraped-down canvas; I always find that it's easier to get into the painting when there's some painterly activity already on the canvas.

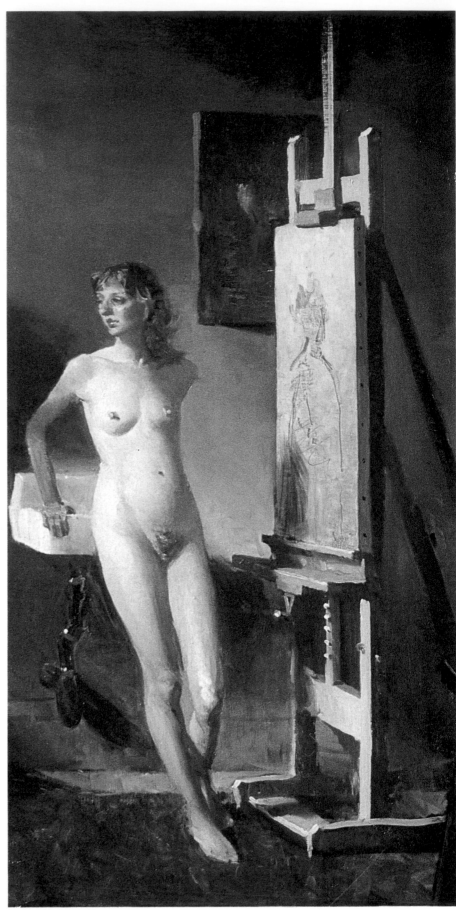

STUDIO NUDE (detail). Fanny Garver Gallery.

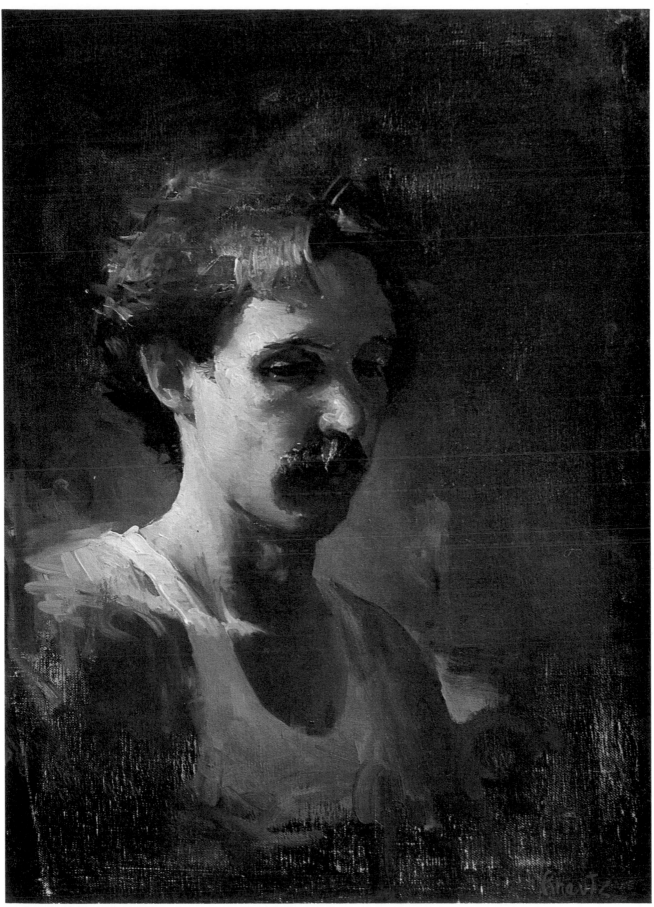

THE ACROBAT. 24″ × 18″ (61 × 45.7 cm). Collection of Gina Kreutz.

Is the Symmetry in Perspective?

Humans are bilateral: one half is mirrored by the other half. As you draw or paint, try to work back and forth, rhyming one side with the other. That's what makes a drawing look solid, what gives it a three-dimensional reality. What complicates matters is, of course, perspective. Visually, the two halves are rarely equal because one or the other of them is turning away from the viewer. That turning distorts, makes things thinner and/or partially obscured. The solution, then, is to describe one half in a straightforward way and show the other half as a receding, distorted, reversed replica. As hard as it sounds, it's easier than copying because it obeys a logic. You can think your way through it.

The head is a natural place to study this idea of distorted symmetry. Unless the head is looking at you straight on, there's going to be a wide side and a narrow side. For some reason, it's difficult to accept how relatively narrow the far side can be. It's a question of really looking. Your mind tells you that both sides of the face are equal so you paint them that way. It's true. They are equal, but perspective is at work. To make your job easier, really look at what's happening in an analytical way, check out what is in perspective, what's being obscured (how much, for instance, of the far eye is being hidden by the nose), and what's being distorted. It used to be debated in art schools whether the realist should paint what he sees or paint what he knows. The answer is probably: paint what you know you see.

The portrait above shows me looking out in full face, with both halves equal in size. The study below shows a three-quarter view. Now the halves are unequal, and the side next to the light has become a thin strip. The near side is much wider. Often the key to figuring out exactly how wide each side is, is to find out where the eye corners are. On the far side of the self-portrait, the corner of the eye is just touching the edge of the nose's top plane. I worked from that point to the outer edge of the eye socket and then to the outer edge of the cheek-bone. On the near side, the corner of the eye falls right at the base of the nose's side plane, and I was able to work back from that point to determine the dimensions of the whole near area. Determining exactly where junctions of form occur is one of the keys to accurate drawing and keeps the picture from becoming a collection of hopeful guesses.

SEATED NUDE (unfinished study). Collection of the artist.

SEATED NUDE

The side to the right is the near side, so it's fuller, more frontal than the side on the left. I was working back and forth here, thinking near and far as I went. (After I'd made this start on the picture, the model worked up a deep tan that didn't go with my flesh-color scheme. I'm waiting until her tan fades in order to finish it up!)

SELF-PORTRAIT. 17″ × 13″ (43.2 × 33.1 cm). Collection of Dorothy Hereford.

SELF-PORTRAIT

The near/far, wider/narrower idea is obvious here. Not only is the right side of the face bigger because it's nearer but it also includes the side plane of the head. This is another picture begun on a gritty, scraped-down old canvas. The color world for the painting was suggested by the earthy brown and orange that were on the canvas before I started. Painting the picture was a matter of pulling the form out of this background color.

OLIVER. 20″ × 16″ (50.8 × 40.6 cm). O'Brien's Art Emporium.

OLIVER

I painted Oliver during a trip to Arizona and my goal was to capture his combination of wisdom and leather toughness. The near side of Oliver's face is broad, the far side narrow. As I painted him I went back and forth, trying to get the near/far balance to work.

To keep the face in sharpest focus I painted the hat and the background in almost the same value. The hatband and the cast shadow on the forehead are evidence of the hat, but the hat itself almost disappears into the background. The white collar becomes a frame for the head. Notice how the sharp, pointed edge against the darker background forces it to protrude, creating a three-dimensional effect.

Color

Color is the most difficult element in painting to get right. To paint a picture with strong value, good design, good drawing, and depth, and still retain vibrant color is really a challenge. The key, I think, is to use color functionally. Don't put in a color merely because it's pretty, but rather use it because it helps the overall effect of the painting. The ideal is to create a coherent color world at the very beginning of the painting. Later in this part I'll talk more about ways to do that, but for now, suffice it to say that the picture should be a view into a world of harmonious interrelated color. The pleasure you get from looking at a beautiful painting is partly the pleasure of seeing different elements fused into a unified whole. The colors Velázquez uses, for example, are not beautiful in and of themselves, but he has used them in such a coherent, functional way that they glow.

I should point out here, by the way, that the kind of painting I like best is not (in fact can't be) as high in color as some of the supercolorful paintings of the Fauves. It seems to be a fact that you can't get a light-filled look and maintain that kind of fresh-out-of-the-tube, high-key color. Light, particularly indoor north light, doesn't permit it. Its inherent coolness softens color, and the need to create space around the light necessitates dulling and muting the background. Even outdoors in direct sunlight, a lot of the colors need to be muted somewhat if a true chiaroscuro effect is desired; if everything has full light on it nothing will look brightly lit. I feel the trade-off of zippy color for a convincing light effect is more than a fair one. Muted color is an excellent stage upon which to create the light drama. I think a picture is more deeply powerful when one colorful element is shining out against darker, duller colors than when a host of flamboyant colors are juxtaposed against each other. Also, at a certain point, too much color doesn't look real, and I think realness should be what the painter is after. Does the color increase the reality of the painting? If it's only being put in because it's pretty or attractive, it weakens the picture. A really great painting is great because it's truthful; it condenses and refines the way things look; it reveals the essences. Color should be in the service of that larger effort.

Is There a Color Strategy?

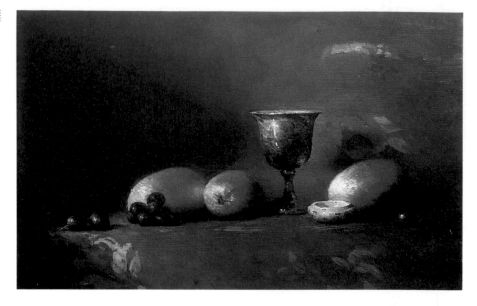

Arbitrarily putting a lot of bright colors on the canvas can create a vivid look, but not necessarily a harmonious one. In order for the artist to achieve harmony there must be a color idea for the painting.

In the section on shape variety ("Are the Shapes Too Similar?" in Part Two), I discussed polarity—how a good painting is a unification of opposing elements: big and small, sharp and soft, dark and light, and so on. A painting looks "in color" when some sort of color polarity is presented. For example, yellow and purple are opposite each other on the color wheel and consequently there's a tension between them. The painter can exploit that tension to create energy in the painting by directing it toward the interplay of those two colors. One of them should be what we could call the focus color, the color of the center of interest, and the other should be the surrounding color. Generally, I would say that the focus color should be the warmer of the two. A green/red painting, then, would describe a red center of interest surrounded by a green environment. The colors needn't be exact opposites for this concept to work. Green and orange or green and purple also create a dynamic. But the colors have to be fairly different; blue and purple or red and orange can look nice together but are too close to work as an opposite-color concept.

Another idea that can be used to give the picture an in-color look is to juxtapose noncolor with color. Noncolor doesn't necessarily mean gray (gray is maybe a little too assertively cold to be neutral); it means a hue that's almost unidentifiable. Something like a dull umber, or a pale olive. In the picture, the effect would be a lot of dull color surrounding a colorful object.

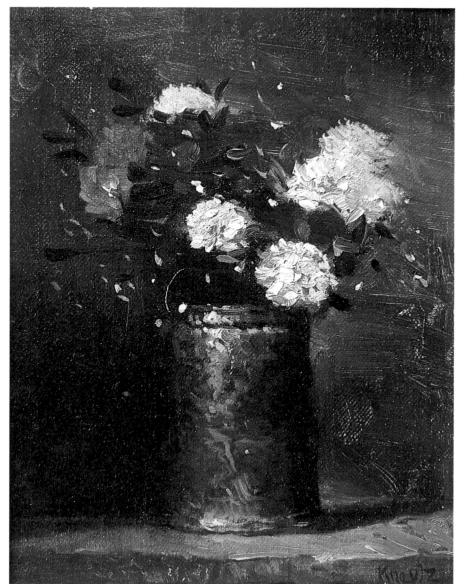

In the still life on the top, the color concept is orange and green. The mangoes look vivid because they're set against the cool green of the background. In the still life on the bottom, color against noncolor is the strategy: the pink of the carnations set against the dull brown of the background.

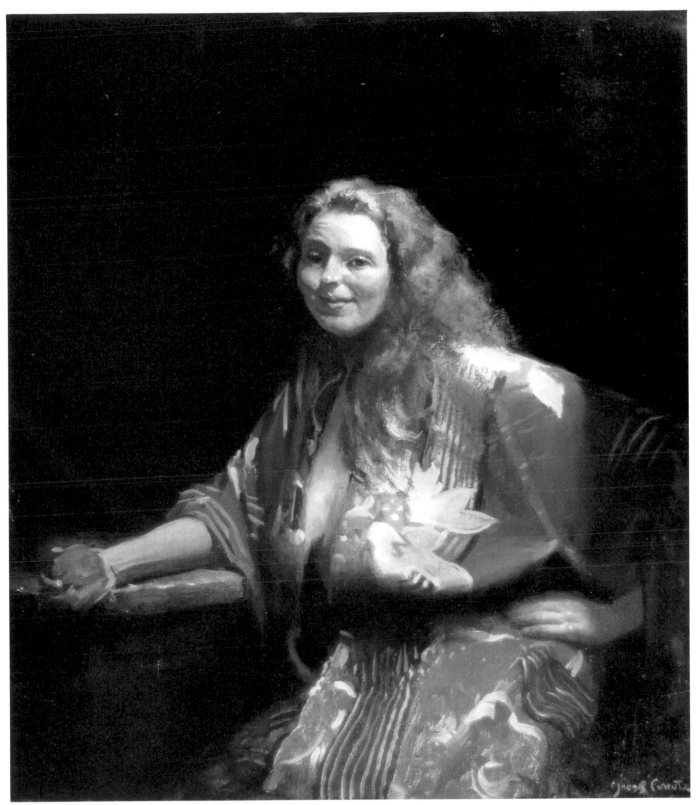

LESLIE. 32" × 24" (81.2 × 61 cm). O'Brien's Art Emporium.

LESLIE

The color strategy here is orange and green. In a sense, everything except the kimono is orange. Leslie's skin, her hair, and even the background are really different values of orange (the background is black mixed with burnt sienna, an orange brown). That color simplicity was used to convey Leslie's quality of immediacy and directness.

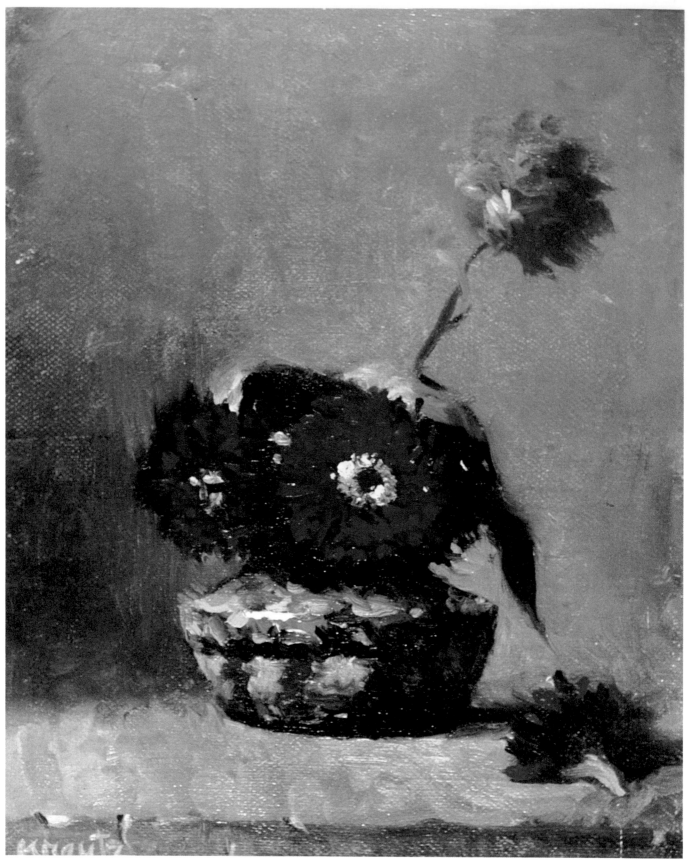

ZINNIAS. 10″ × 8″ (25.4 × 20.3 cm). Collection of John and Leone Suttie.

THE BLUE BOAT. 12″ × 15″ (30.5 × 38.1 cm). Grand Central Art Galleries.

THE BLUE BOAT

Here's color surrounded by noncolor. I painted this picture on an overcast, foggy day, and the blue of the boat was the brightest thing around. For the noncolor parts, I mixed Venetian red, cobalt blue, and white. For the sky I used more white, for the storage hut, less.

ZINNIAS

Red and green are the opposing colors in this picture. I think the red here looks especially vivid because it's set up against an almost mint green. To increase the atmospheric quality in the painting, I put a lot of background color into the tallest receding flower, and also softened its edges.

Could Purer Color Be Used?

Colors dull as they're mixed together. It's commonly said that you shouldn't use more than three colors in a mix, and while I frequently find myself edging over that limit, I think the principle is sound. In the first place, more than three colors is redundant; if you're mixing a brown, and you've used red and yellow and blue, and you then add orange, you're repeating what the red and yellow have already achieved. The second reason to limit your choices is that you want the mixtures to solve problems rather than create them. In other words, the components of the color you want shouldn't be so numerous that you have to spend a lot of time refiguring out what they were and how much of them you used. The process should be: "This flesh color could be approximated with orange and white and blue." From that point on the only decisions to make are proportional. That's the ideal. The reality (my reality, anyway) is often sloppier and less thought-out, but I think it's good to at least have a higher process to aspire to.

If you're painting something with a lot of color in it, try to match that chroma with pure color. If someone's wearing a brightly colored shirt, or a flower has some bright petals, that's the opportunity to use some straight-out-of-the-tube vividness. Sometimes you can get so used to modifying and toning down the colors on your palette that you're reluctant to use the un-mixed color that's there. But it's a terrific effect to have some vibrant hue shining out against muted surroundings. In Rembrandt's time, colors were expensive, and bright colors were the most expensive of all, so artists would build their whole pictures around a small bit of these beautiful hues that cost so much. They showcased the color the way a jeweler showcases a diamond. Today, when oil paints are so accessible and no tube of paint costs more than ten dollars (more or less), it's easy to lose that reverence and either put bright color everywhere or dull it everywhere.

In the still life on the top the nectarines are painted with a low chroma; the color fits into the color world of the painting almost too well and there's no color excitement being generated. In the still life on the bottom I got out my bright cadmium reds and oranges and applied them directly onto the nectarines. Getting some strong color into the picture gives it flair and presence.

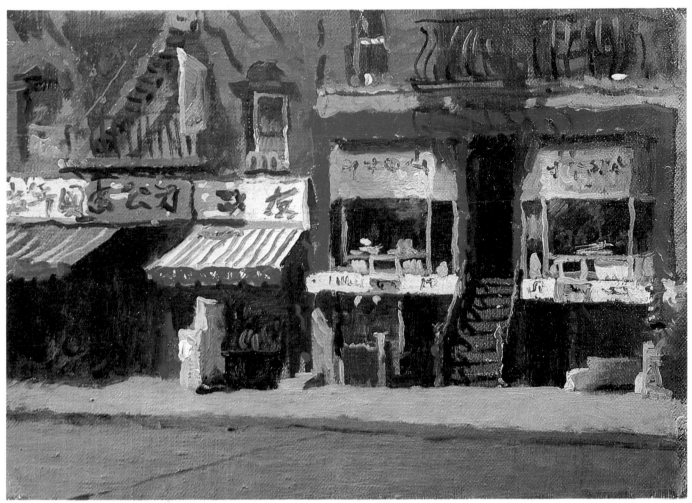

CHINATOWN, EARLY SUNDAY MORNING. 10" × 15" (25.4 × 38.1 cm) Grand Central Art Galleries.

CHINATOWN, EARLY SUNDAY MORNING

The red of this storefront in New York's Chinatown was what attracted me to the scene, and when it came time to paint it I used cadmium red right out of the tube. The street was jammed with people but they were moving so fast I didn't think I could get any of them into the picture convincingly. I planned to put some in when I got back to my studio, but decided I liked the picture the way it was.

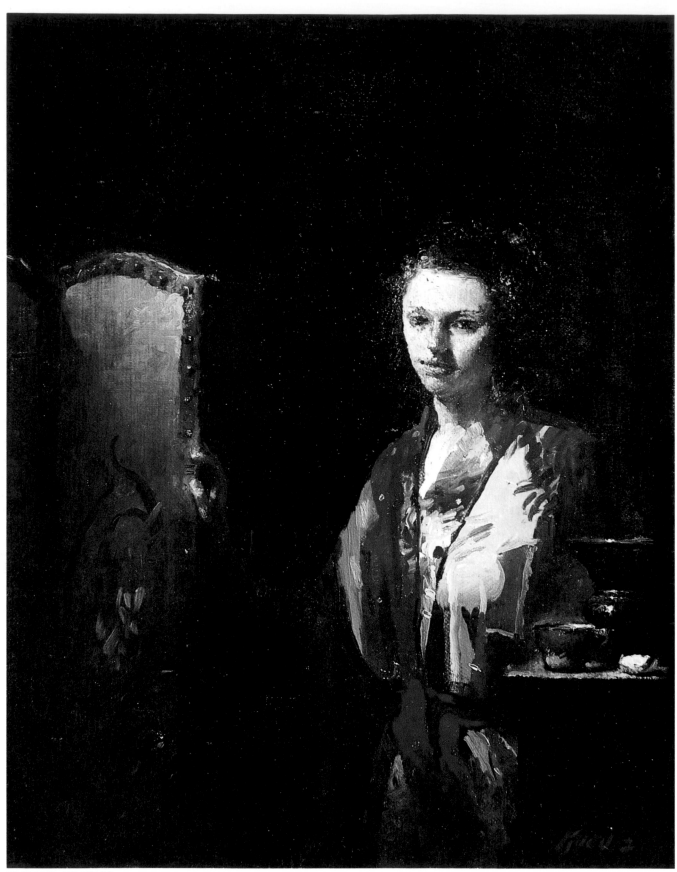

THE RED KIMONO. 19″ × 15″ (48.2 × 38.1 cm). Private collection.

THE PAWNSHOP. 12" × 18" (30.5 × 45.7 cm). Collection of Bernard and Toby Cohen.

THE RED KIMONO

The red of the robe was the dominant color note in this picture, and I related all the colors to it; I wanted it to shine out. At the sash, I used pure cadmium red.

THE PAWNSHOP

The color here is not particularly vivid except for the sign at the right, for which I used straight cadmium yellow deep. The sign *was* that color, and I think this jazzy note helps convey the nitty-gritty look typical of New York's lower Fourth Avenue. I set up here to paint just because I like the look of this storefront. When I was nearly finished with the picture, though, a window shopper strolled into view and stood there studying the merchandise until I'd finished painting him in. Sometimes these accidental moments are just what's needed.

Do the Whites Have Enough Color in Them?

Things that are white—clouds, table-cloths, snowbanks, refrigerators—can't be painted with straight-out-of-the-tube white. A false white needs to be mixed up that looks the way white does in the picture's color world. Why doesn't straight white work? Because there's always some part that's brighter than another part. A refrigerator, for example, will go from a dark shadow plane, to a middletone plane, to a light plane, and finally, along the edge facing the light, to the highlight, each step getting brighter and bright-er. None of these different facets of one "white" object is really white. The problem of what color to use for dark white isn't usually solved with gray. Gray looks like gray, not white. If you're painting white sheets and you use a flat gray to depict them, they'll look like gray, which is to say dirty, sheets. The best way to get it, I think, is to use the color world of the painting as a guide. White in a greenish tonality would have a green cast to it, white in a blue tonality would have a blue cast, and so on. If your painting is built around an orange/blue color strategy, orange and blue and white mixed together should create the right kind of neutral "dark" white you need. Complements mixed together neutralize each other, and if you add white they make a nice dark neutral that will fit into the color scheme.

In the still life below, the white cloth was created by mixing white into the burnt-sienna and cobalt-blue components of the background color.

WHITE SATIN

The problem here wasn't just white, but shiny white. This satin robe was highly reflective. Since the background was a warm olive brown, I used cerulean blue, orange, and white to create a rich-looking "dark" white. Only in the highlight along the top of the robe's lapel do I get anything like pure white; the rest of the robe is much darker except for the occasional highlights along the fold edges.

The lighting in this picture is a little unusual for me because so little of the model's face is directly lit by the light source. The near side of her face would be in dark shadow if it weren't for the reflected light coming up from the robe. I found that effect useful because it not only helped describe her features but it also made the robe look brighter: the more reflected light there is, the brighter the object causing the reflection will appear.

TWO BOATS

There's a lot of white in these boats, but most of it's in shadow. Outdoors, that means that there's usually sky color reflected into the shadow area. In this case I used almost exactly the same color for the sky as I used for the white in shadow: cerulean blue and white with a touch of cadmium orange. For the white part of the boat in light, I used white and cadmium yellow.

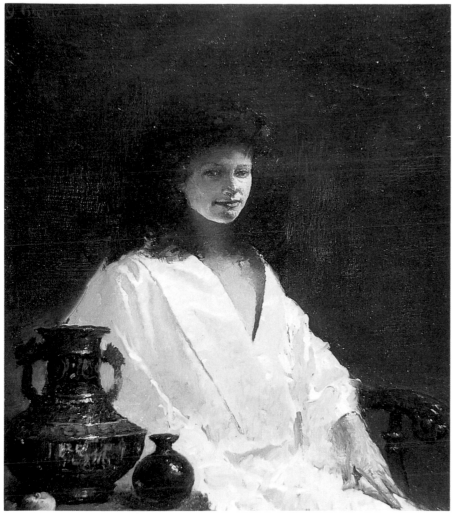

WHITE SATIN. 24" × 18" (61 × 45.7 cm). Collection of Karen Bushé

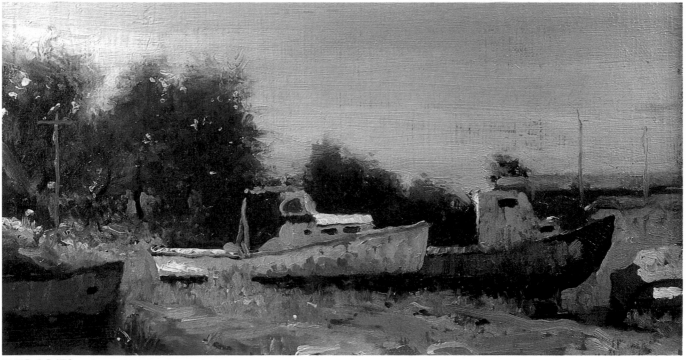

TWO BOATS. 9" × 12" (22.9 × 30.5 cm). Collection of Gina Kreutz.

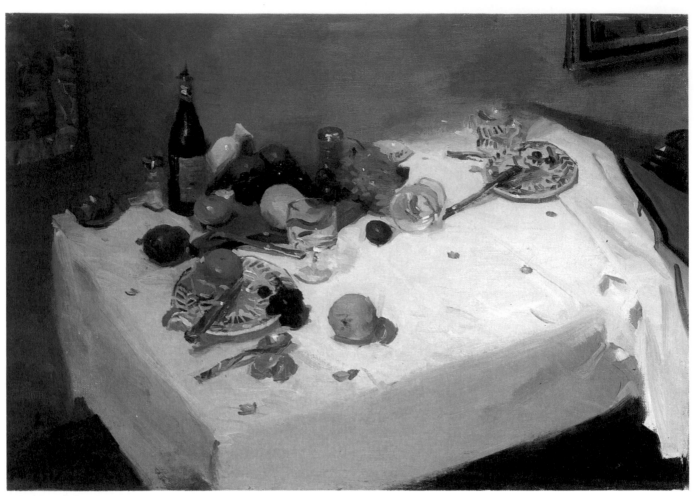

DESSERT COURSE. 16″ × 23″ (40.6 × 58.5 cm). Collection of Keith and Bernadette Keenan.

DESSERT COURSE

The tablecloth here was a bluish white, so I used a mixture of cobalt blue, orange, and white. There was a partial cast shadow on the lefthand side of the table so I used less white in that area. I painted this after I'd gotten tired of setting up formal arrangements on shelves. Looking down at a whole mass of clutter was a nice change.

MRS. LUNNING'S BATHROOM

There's a lot of white to deal with here. The only relief from it are the washcloths, the mug, and the shower curtain. Yellow ochre, green, and white are what I used to simulate the white of the walls, and for the towels I added a little blue to the mix. What I liked about this bathroom, and what I wanted to try and capture, was the flow of light from the high window.

MRS. LUNNING'S BATHROOM. 18″ × 32″ (45.7 × 81.2 cm). Private collection.

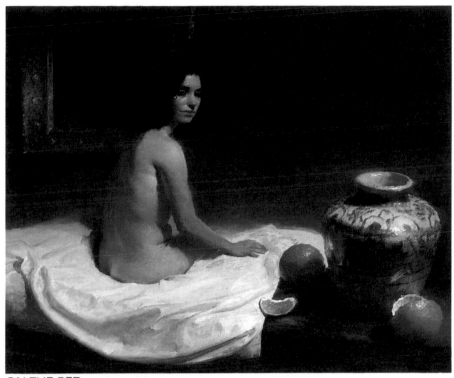

ON THE BED. 18″ × 24″ (45.7 × 61 cm). O'Brien's Art Emporium.

ON THE BED (DETAIL)

These sheets were created by using the raw umber of the background color and some cobalt blue with varying degrees of white. In a couple of places, where the light was really strong, I used white straight out of the tube.

Are the Colors
Overblended on the Canvas?

Blending, as a way to effect a transition between two areas, works, but to my mind it's an unsatisfactory solution to the problem. It doesn't contribute to the logical structure of the picture. For the painting to give satisfaction to you while you're painting, and to the viewer afterward, there must be a sense of problems being solved. A great painting is a harmonized collection of elegant solutions. The problem of creating a transition is solved when the solution is based on the whole color and tonal world of the painting. Simply to blur that tricky area between two planes or objects dodges the issue. The picture may look alright, but the artist hasn't learned anything about how to paint, how to apply wet pigment onto the canvas in such a way that abstractions and illusions occur. Blending, it seems to me, is not a part of that effort.

In less grandiose terms, blending is also a problem because it's not clear where to stop. Once you start feathering little passages here and there, you want to do it everywhere and the picture gets softer and softer. Reworking areas becomes difficult because the perimeters are so vague that you can't tell where one passage ends and another begins. Gradually the picture starts sliding into the mud.

I like to try and mix up a color that will provide a bridge between two areas. If I'm painting a face and I feel that the edge where light and shadow meet seems too sharp, rather than blend it to soften it, I might mix some dark halftone (maybe background color) and put it along the edge of the light side. Remember: the shadow doesn't get lighter as it nears the light; the light gets darker. The closer in value that that middletone gets to the shadow value, the softer-looking the transition will appear.

I painted the pear above with a lot of soft strokes that I then feathered together. It's all transition. In the pear below, I let each stroke stand by itself. In going from the light to the shadow, for example, I mixed and applied a distinct light color, a distinct halftone color, and a distinct shadow color. There's very little blending. The lower pear, to my eye, has more substance and more personality. When too much blending occurs, the character of the object and the character of the painter start to disappear.

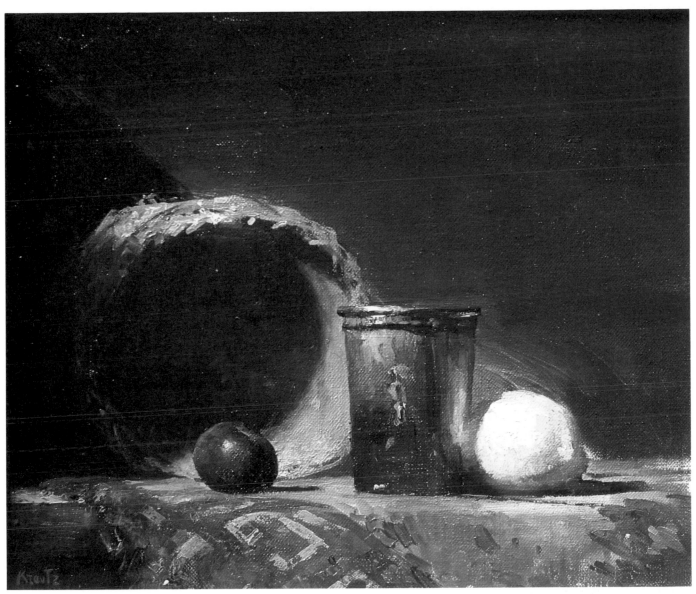

STILL LIFE WITH LEMON. 13" × 16" (33.1 × 40.6 cm). Private collection.

STILL LIFE WITH LEMON

The transitions here aren't softened at all. The light goes pretty directly into the shadows. I think the fact that the light is so bright makes you not notice how abrupt the transition is. It's hard to focus on an edge if the light within the edge is made too compelling.

PERCY'S SHED, CHÂTEAU DE RÔCHE. 14″ × 17″ (35.6 × 43.2 cm). Private collection.

PERCY'S SHED, CHÂTEAU DE RÔCHE

Here's some direct painting: trees, leaves, tiles, stonework are all painted in directly with hardly any blending. I painted this picture on a salmon-colored ground that corresponded nicely to the color of the shed wall, which is the middletone of the picture. With that color taken care of, I moved into the darks (the underplane of the roof, the doors, and the trees) and then into the lights. The effect I was trying to re-create was the way the light almost slid off the roof and landed on the grass and pathway.

SOHO STOOP. 16" × 13" (40.6 × 33.1 cm). Collection of Dale and Lynn Rhyan.

SOHO STOOP

I painted this picture in a direct, stroke-by-stroke approach. This kind of scene didn't need any blended transitions. I wanted an immediate, gritty effect and smoothing things out would have softened it too much. The only exception to that was the underplanes. Since this is a top-lit situation, I needed to make sure that the areas facing away from the light were in shadow—and shadow, to look like shadow, needs be fairly dark and smooth.

Would the Color Look Brighter If It Were Saturated into Its Adjacent Area?

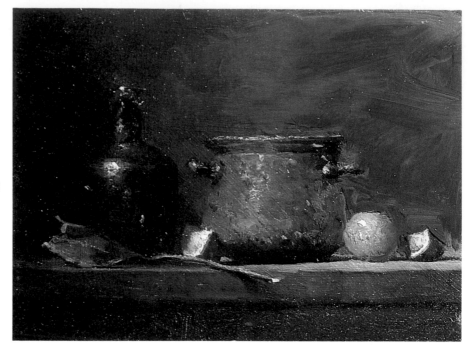

I discussed in Part Four how things can be made to look brighter by having the light "burn out" the dark ("Would the Light Look Stronger with a Suggestion of Burnout?"). Color can be made to look more intense by a similar approach. Bright red looks brighter if a red glow emanates from it. Yellow looks more yellow if it permeates the atmosphere around it. The message being sent to the viewer is: this color is so intense the air is saturated with it.

In the still life on the top, each object's color is kept within its own boundaries; nothing spills over. In the still life on the bottom I let it flow out. As the background nears the orange, for example, it starts getting more of the orange's color in it. The copper pot also gets some of that glow. The general idea is: the brighter you want the color to look, the more it should affect the areas that are near it.

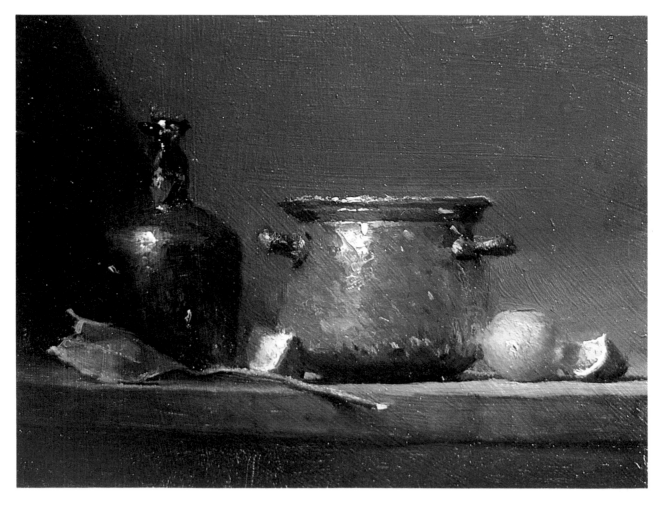

MARITTA'S ROOM

The rich burgundy color of the walls was made to look even richer by floating some of it into the white elements in the room. The fireplace, the chairs, the mirror, and the girl reading are all affected by this color. If I hadn't put any of it into the white, the burgundy wouldn't have looked as intense.

I started this painting as a simple cool-light/warm-shadow composition, but as the day progressed an annoying piece of orange sunlight came into the room and threw everything off. I tried to ignore it for a while, but finally decided it would give the picture a lift. Looking at it now, it looks like the element that the whole picture was built around.

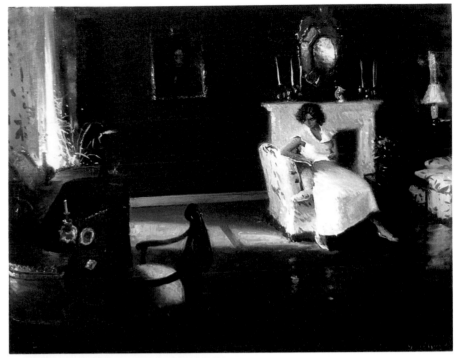

MARITTA'S ROOM—AFTERNOON SUN. 30" × 40" (76.2 × 101.6 cm). Collection of Kirbie Knutsen.

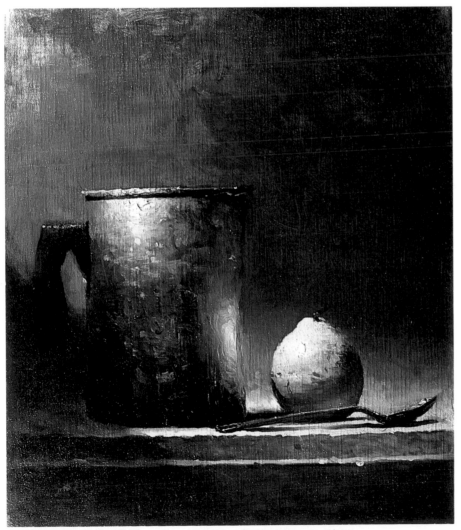

COFFEEPOT AND PEAR. 20" × 16" (50.8 × 40.6 cm). Private collection.

COFFEEPOT AND PEAR

The yellow pear was the climax and focal point here and I wanted to make it as intense as possible. So I used its yellow color to lighten up the atmosphere around it and to put a bright reflection into the coffeepot. Purple and yellow are complementary colors, and I was trying to paint the coffeepot in such a way that it would be more a part of the background than the pear; consequently, I painted it with a lot of the background's purple-gray mix.

Part Nine

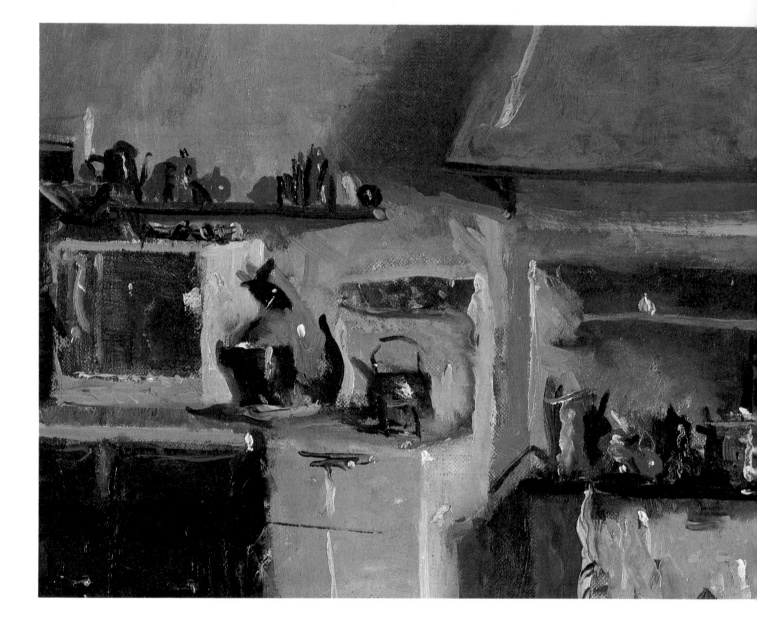

Paint

There's a visual vibration that occurs when the reality of the image on the canvas is communicated with undisguised paintstrokes, when the picture is showing its content *and* its form.

The viewer becomes involved with the painter in making the transition from reality to canvas. When that effect isn't happening, when the painting is so carefully nuanced and blended that no paintstroke is visible, there's less for the viewer to do. The translations are hidden, and the viewer, consequently, can't enjoy them. When the painter uses a big, unselfconscious piece of paint to represent a nose, for instance, there's a sense of shared enthusiasm.

Also, making the paintstrokes visible adds an extra esthetic dimension to the picture. The viewer is shown not only the composition, the subject, and the light effect, but also a mosaic of paintstrokes. Some may be thin and transparent, some thick and opaque, some drybrushed, some applied with a lot of medium; together they create a varied paint surface that enriches the picture.

One reason I prefer realism to abstract art is that realism can present a multitude of painterly effects that can be beautiful by themselves but that also convey the artist's perception of the real world. I feel that a realistic picture gives more to the viewer, offering more levels to which the viewer can respond.

Is Your Palette Efficiently Organized?

Painters' palettes invariably look like their paintings. A palette with globs of dried paint, colors squeezed out wherever there's room, and only a little gooey area to mix on, can only result in a messy picture. Likewise, a sheet of white paper with tiny drops of paint squeezed around the rim couldn't ever produce a painterly painting. Palettes have to be well-enough organized so that the artist can move fluidly from thinking to mixing to painting. Making pictures is hard enough without the material and craft side of it holding you back. Organizing your palette is good for your painting because it makes a statement about your intentions. It says, "This is serious." The alternative, having the craft side of your efforts be inefficient, is tempting because it lets you off the hook. If your tools are meager or sloppy, you, the artist, can't be held responsible if the painting doesn't work out. To actually take control of the situation and make your material more functional can be difficult.

Also hurting the craft side of painting is the suspicion that there's something unartistic about keeping things too tidy. The artist looks most artist-like when he or she is covered in paint and squeezing colors out onto any surface that's handy. But art is not being served when red is wanted, can't be found, and brown used instead. Or when a big juicy stroke would look good, but because of low paint outlay a tinting dab has to suffice.

On days when I'm painting, I spend about forty-five minutes setting up my palette. That means cutting the skin off the dried paint and removing the wet from inside. I then add some new paint to the little puddle of just-excavated stuff, and put it back on its pile.

After I've done that to all the paint piles that need it, I take some alcohol and clean off the mixing area. I use a glass palette in the studio because it's so easy to clean.

By the time I'm finished, I'm ready to paint. Because I've been fooling around with the paint for all that time, I feel warmed up to it. I'm in a more painterly frame of mind than if I'd just started off cold.

As I paint throughout the day, I keep my palette organized and looking coherent, scraping it clean with a razor blade every so often.

As organized as this sounds, I've still found a way to get paint on all my clothes.

As you see, I've organized my palette in a general light-to-dark sequence. Also, I've assembled the hues into color groups: the blues are together, the browns are together, the cadmiums are together.

Is the Painting Surface Too Absorbent?

The quality of a painting can be held back by poor canvas, and almost all commercial canvas *is* poor. It's too absorbent. The paintstrokes are sucked into the weave; it's as though you're tinting the canvas instead of painting on it. The problem is that commercial manufacturers use too little primer; they simply wash over the cotton with a little gesso. For oil paint to work the way it should, it needs to be applied to a surface that will let the strokes retain their integrity.

My method of preparing canvas is a time-consuming workout, but it pays off when it's time to paint. I buy a big role of Belgian linen and stretch it over a 4′ × 10′ frame. I apply two coats of rabbitskin glue, sanding after the second coat. Then, with a palette knife, I cover the canvas with white lead, trying to eliminate all ridges as I go. The goal is to fill in all the little holes between the threads of the canvas. After that coat is completely dry (it takes about two weeks), I palette-knife on one more coat. When that coat is dry, I can cut whatever size I need from the big canvas and stretch it onto smaller heavy-duty stretchers. Once you start working on palette-knife lead-primed canvas, you'll get hooked.

Another option, if the lead-priming route seems too laborious (or dangerous): get some Masonite cut to whatever painting size you like, and then brush on a couple of coats of gesso. The resulting surface, while not quite as satisfying as lead-primed linen, is still better than commercial canvas. The only problem is that you can't go much bigger than 18″ × 24″ because the boards tend to warp.

When I'm traveling and painting I use a combination of the two ideas: I take along a lot of little scraps of canvas in a mailing tube. When I want to paint, I just tack one of these onto a plywood panel. Back at the studio,

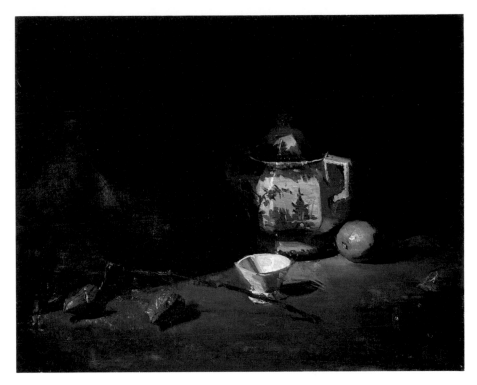

when everything's dry, I glue it onto a Masonite panel.

One factor I should point out is that if you've gotten used to commercial canvas, lead-primed will at first seem difficult to handle. Because it's not absorbent, every stroke and squiggle shows up. If you're not used to that sort of exposure, it can feel strange. On good canvas, it's actually hard to get a smooth, slick passage. For a background (which you usually *do* want to be smooth), you often have to put on two or three coats. That doesn't have to be a real drawback however. It just means you've got to alter your pace a little. The fact is, you *want* your picture to be expressive, and canvas that shows off the strokes you use *is* more expressive.

In this still life, I used the texture of the canvas itself to indicate the rough surface of the tabletop. I also let the canvas show through in the shadow area to suggest, rather than show, the presence of other objects.

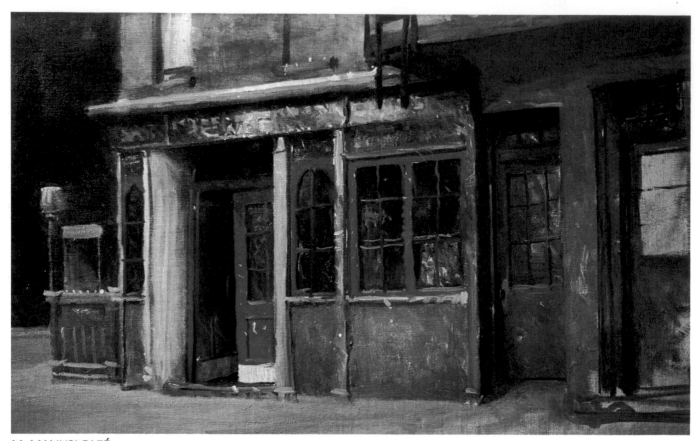

McMANUS' CAFÉ. 14″ × 21″ (35.6 × 53.3 cm). Private collection.

McMANUS' CAFÉ

The lack of absorbency here is apparent, particularly in the gray doorway area on the right side of the picture. I was working on a tan-colored ground and I consciously didn't try to cover it very thoroughly, except in the center of interest, the open doorway to the bar. I had been admiring the look of this café for a few months before I finally got around to going over and painting a picture of it. The day after I did they repainted the place brown.

DAISIES AND COFFEEPOT

The rough board floor in this setup was a natural place to exploit the look of toned canvas bleeding through a transparent color. If this had been commercial canvas the undertone would have been completely covered by the color of the boards.

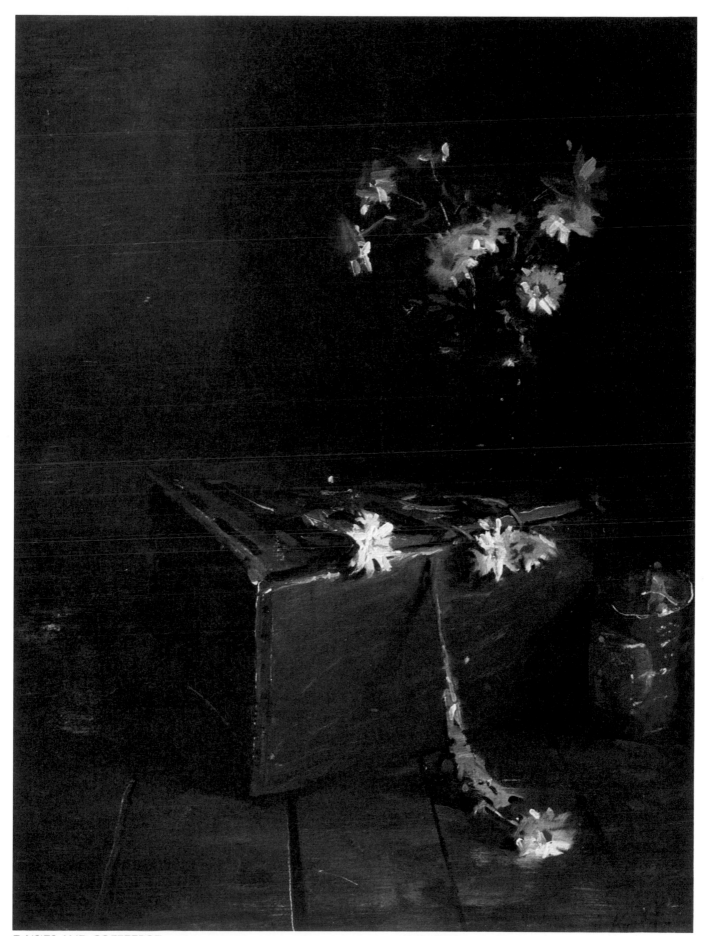

DAISIES AND COFFEEPOT. 20″ × 16″ (50.8 × 40.6 cm). Collection of John and Ticker Ballard.

Are You Using the Palette Knife as Much as You Could?

If you think you need to loosen up (for some artists tightening up is what's wanted), palette knives are good tools to help you do it. I've had quite a few experiences in which the picture was going nowhere and in a fit of pique I attacked the canvas with a palette knife, scraping off most of the wet paint and generally smudging everything around. I'm always surprised at what an improvement it makes, and from there I'm usually able to get the painting back on the track. I'm not recommending tantrums as a way to solve esthetic problems, but there is a sense in which scraping can open up new possibilities. For one thing, scraping the picture eliminates meaningless detail. Because the palette knife is spreading tiny flecks of paint around and exposing the dense, textured look of the canvas weave, it creates the illusion of detail without stultifying the picture. Also, by mushing everything together, it unifies the color world. It pushes some of the red into the green part of the picture, and so on.

It can also have a good psychological effect. Painting requires such a strange blend of insightful accuracy and carefree bravura; you want to express things precisely but never get so tight that you're afraid to throw in the big expressive stroke. You always want to keep the process fluid and painterly. Scraping and smudging every now and then can keep you from getting too concerned with minutiae.

Palette knives are also good for putting paint *on* the canvas. Areas where the light is strong can be intensified by applying thick paint with a palette knife. Palette-knifed globs always make good highlights.

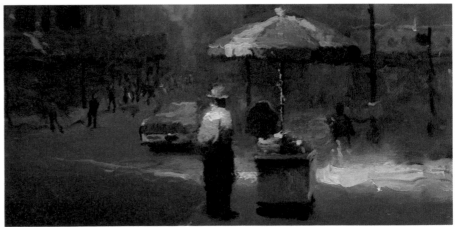

In the detail at the top, I painted a grayish color where I wanted the highlight to be, and then I used a palette knife to apply a big glob of bright gray (white with a little black) paint in the center. I also used the palette knife to scrape paint off the surface of the pot to indicate parts of the pattern. In the detail below, I tried to capture the effect of a streaking shaft of light by using a palette knife to pull a load of white and orange paint across the canvas. This thick palette-knife work provides a contrast with the thinly painted shadow areas that make up the rest of the painting, emphasizing the sharp brightness of the slice of light.

IMARI PLATE

I used the palette knife throughout this painting, most noticeably in the flower petals, to make the thick highlights on the brass pot and the wine bottle, and all over the tabletop in order to simulate its rough texture. This is a "reading-into-the-picture" kind of painting: I set it up so that your eye starts at the lower lefthand corner and is led by the props and the light to the plate in the upper righthand corner. This type of composition always requires a looking-down perspective.

IMARI PLATE. 18" × 24" (45.7 × 61 cm). Collection of John and Betty Batson.

THE RED WALL

There's a lot of palette-knife work here. The task was to try and approximate the layers of torn posters and faded paint that gave such a distinctive look to this red and olive wall. Once again, I was helped by starting on an old canvas that already had some texture on it. Just by scraping and drybrushing reds and blues and greens, I was able to get the desired effect.

THE RED WALL. 20" × 16" (50.8 × 40.6 cm). Private collection.

Are You Painting Lines When You Should Be Painting Masses?

A picture can be linear or it can be painterly. Oil paint, because of its thickness and wetness and clumsiness, works better if it's used in a painterly way. Gouache, blockprinting, etching, and certain types of watercolor techniques are in the domain of the linear. People who have spent a lot of time drawing often have trouble getting the feel of the painterly approach. They start their paintings with a carefully outlined drawing (sometimes even using pencil or chalk) and then methodically paint in between all the lines. In the end, their pictures look like what they are: colored drawings. The difficulty is in the thinking. If you see external reality as a collection of outer edges to be copied, the picture will look flat. The painterly approach is to see reality as a series of near and far volumes. Instead of expressing them with outlines, express them with blobs, smears, dribbles, and splotches of paint. Your painting should begin with a series of these spots and as it progresses should grow into more coherent descriptions.

In the still life on the top, I've drawn the setup carefully. It's accurate, but it doesn't seem evocative; there's nothing there to pull me into the picture and get me to painting. In the still life in the center, my start is just a blur, a generalized description of the volumes. My main interest is in getting the placement figured out and suggesting the desired color world. In the bottom picture, I've expanded on the painterly beginning a little bit to show how I would proceed with this painting. The refinements that I will introduce later on in the picture will (I hope) be painterly refinements, touches that may be precise but are still painterly in nature.

NEWSSTAND (detail). Private collection.

NEWSSTAND

I combined loose strokes of paint with silhouettes of color to convey this sunny scene. The smoke provided a convenient way to soften things up a little, to make some of the edges less defined. Sometimes the hassle of painting out on location is a plus. There are so many distractions and time is at such a premium that putting in a lot of details isn't an option. Circumstances force you to depict things quickly and efficiently. The flip side of that, however, is that you can't fine-tune your painterly statement; things can often look a little raw.

CORNER STOOP. 16″ × 11″ (40.6 × 27.9 cm). Collection of Dr. and Mrs. James L. Weese.

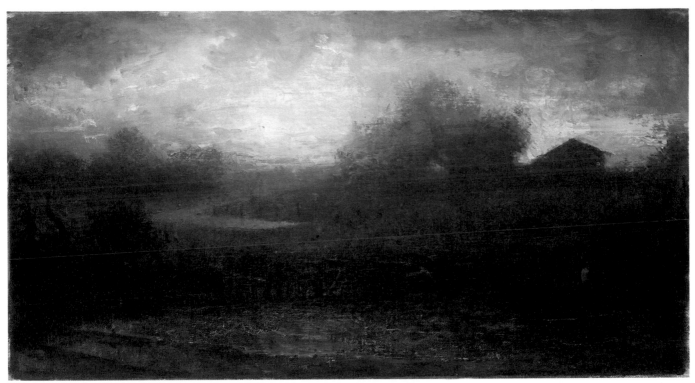

DEVIL'S RIVER, SUNDOWN. 12" × 21" (30.5 × 53.3 cm). Collection of Sherrie McGraw.

DEVIL'S RIVER, SUNDOWN

This picture was begun at dusk at the river's edge. Speed was of the essence and a careful, drawing-type of approach wasn't feasible even if I'd wanted to use one. Basically, I blurred in everything, using the palette knife for the edges of the scrubby trees. I refined it a little back at the studio.

CORNER STOOP

Here I was trying to use the paint and the canvas in a way that would convey the action on a busy street corner. I started the picture with blurry shapes and gradually refined the areas that I thought were significant. This kind of painting is more sculptural than if I had started with a carefully drawn outline of the scene.

Are the Edges Dynamic Enough?

There are so many problems to solve in painting that often you feel there isn't time to worry about edges. But a lot of the problems that seem to be about color or drawing or values can actually be solved through careful edgework.

What does good edgework mean? First of all, it means an alternating pattern of hard and soft edges. No edge along a form should continue for very long to be either hard or soft. It should alternate between the two. The outer edge of an arm, for example, shouldn't be razor-sharp from shoulder to wrist. The artist must find places where the edge is softer. The bottle in these still life samples shows what I mean.

ost and found is one way to think about edges, hard and soft is another. The general idea can be stated like this: beginning edges are hard, turning edges are soft.

Hard and soft, lost and found, stop and flow; a picture needs that sort of rhythmic alternation to give it vitality. If all the edges are too soft, the picture gets a fuzzy, dreamy look. If they are all hard, the picture gets cut-out looking. Hitting the right balance is the goal.

In the still life on the top, the bottle's outer edge is hard and sharp from top to bottom and the effect looks cut out. The still life on the bottom shows modulated edgework, which makes the bottle seem to be existing in space and atmosphere.

STILL LIFE WITH SILVER AND APPLES. 18″ × 24″ (45.7 × 61 cm). Private collection.

STILL LIFE WITH SILVER AND APPLES

Edges also tell what sort of substance is being depicted. This picture of a silver cup is a good example of using edges to convey the quality of a material. Silver, being very reflective, appears as almost a composite of its environment. Surround it with a red cloth and it will look red, blue cloth and it will look blue. In this setup, I discovered that the background shadow color, a deep greenish brown, could be so reflected into the cup that the cup's edges disappeared. The highlight on the lip and the apple reflections are the only evidence of the cup's whereabouts.

THE BLUE AND WHITE POT

In this painting, the beginning edge of the orange (where the light first hits the crown) is bright and crisp. Where the light is turning into shadow, however, the transition is more gradual and softer. The new form (the tabletop) comes out of the cast shadow with a sharp edge. Soft, turning shadows and hard cast shadows are an effective way to describe form.

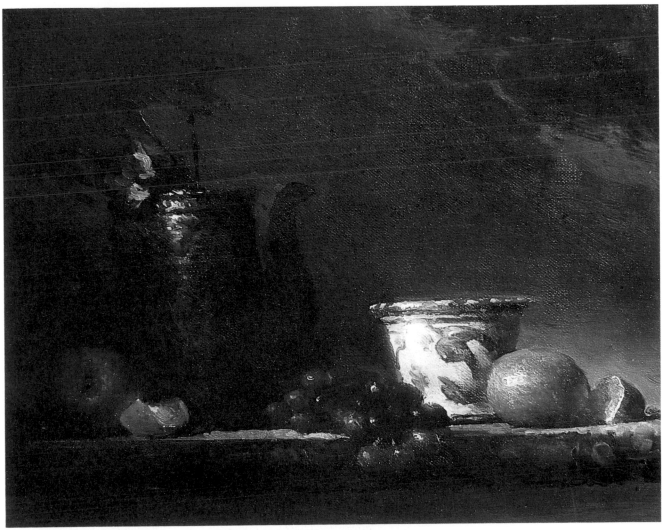

THE BLUE AND WHITE POT. 16″ × 20″ (40.6 × 50.8 cm). Private collection.

LEFT-BANK CORNER. 10″ × 15″ (25.4 × 38.1 cm). Fanny Garver Gallery.

LEFT-BANK CORNER

In this painting I used edge quality to create more depth. The edges harden as they get nearer. The building across the street in the distance was rendered with soft edges and low-value contrast.

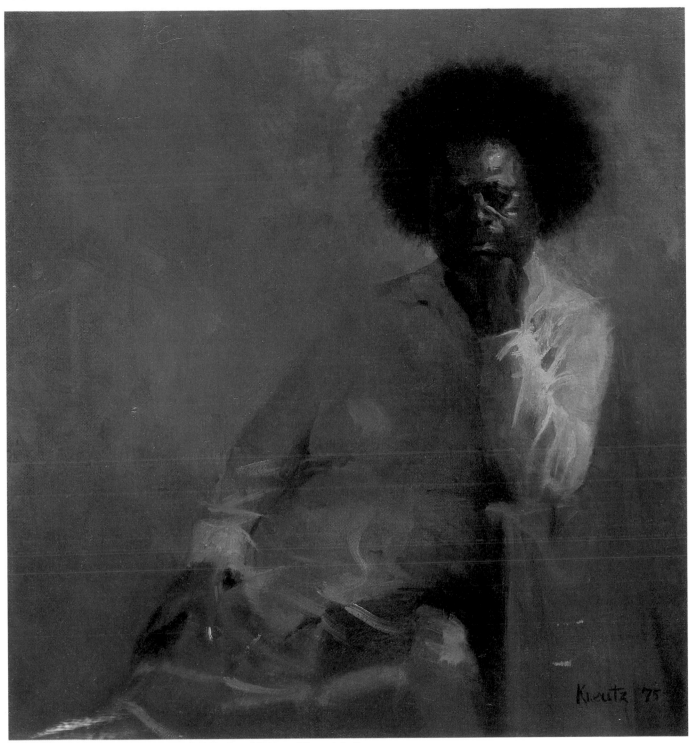

WINNIE. 16" × 14" (40.6 × 35.6 cm). Collection of Keith and Bernadette Keenan.

WINNIE

What kept the edges from getting too harsh in this picture was the discovery that the sitter's right shoulder (the one in shadow) was pretty much the same value and color as the background. I was then able to merge them. This is a warmer, more colorful picture than I usually paint, and it was fun to do for that reason. One of the problems with painting people is that as they pose they get less and less animated, so that after a few days they can look downright grim. People sometimes ask me why the people I paint look so sad. I don't ever mean for them to look that way; that's just how someone sitting still for a long time inevitably looks.

Is There Enough Variation in the Texture of the Paint?

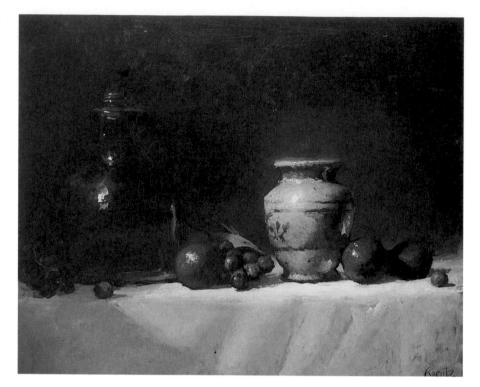

In realistic painting, paint is a metaphor for the illuminated world, and thick paint can provide a good simulation of what light looks like at its most intense. The brighter the light, the thicker the paint. Following through on that idea means making dark shadowy areas thin and transparent, depicting them with smooth, flat paint. The mysteriousness of shadow is best conveyed by a flat treatment. Lack of texture gives the eye nothing to focus on and makes the area in question look deep and mysterious.

A thick glob of paint, on the other hand, is much more suggestive of light. Its thickness creates a natural focus and also provides different facets for the actual light to shine off of.

Like dark and light, or green and purple, thick and thin provide a visual opposition pattern that gives dynamism to the picture. If it were painted entirely with thick paint or entirely with thin paint there would be a static, unrelieved quality to the picture. Interplaying the two polarities gives resonance.

The still life here shows some of the textural effects I'm talking about. The background in particular reveals the different effects that varying degrees of opacity make. The area right around the pot is painted with an opaque, greenish color that suggests airy depth. Farther away from the pot the paint is applied more transparently, and its canvasy, brushstroke look provides a contrast to the smooth area. Leaving obvious traces of the paint application evident in some areas makes the areas where there's no paint texture look even more seamless and airy. On the pot itself I used fairly thick paint, and when I got to the highlight I used the palette knife to get a really big glob of it on.

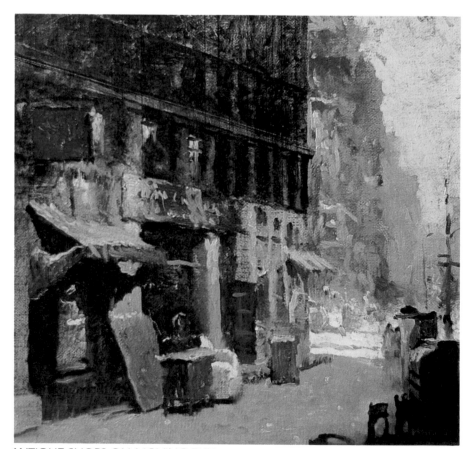

ANTIQUE SHOPS ON MOVING DAY. 12″ × 15″ (30.5 × 38.1 cm). Private collection.

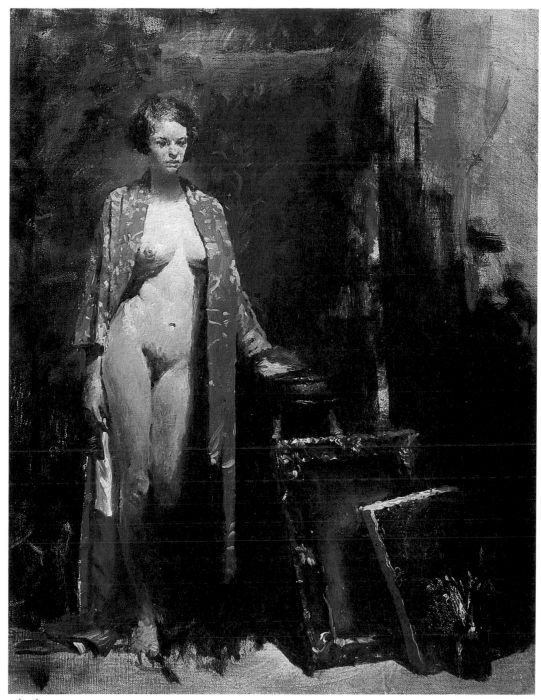

RÉNÉ IN THE STUDIO. 18″ × 24″ (45.7 × 61 cm). Private collection.

ANTIQUE SHOPS ON MOVING DAY

Like *Downtown Sabrett Man* (p. 142), this picture is mostly in shadow. I used thin paint throughout the entire dark area. The light, which is shooting into view on the next block, is depicted with thick strokes of orange and white. One advantage of these in-the-shadow setups is that you can see what you're doing as you're painting because you're standing in the shade. Out in the bright sun there's so much glare that it's hard to make out what's going on.

RÉNÉ IN THE STUDIO

The thick-and-thin pattern was organized around the central figure: the closer to the focus, the thicker the paint. The peripheral areas of the picture are just thin washes of burnt sienna and blue. The impasto corresponds to the light intensity. I left the picture in this unfinished state because I felt that showing some of the picture's process fit in with its subject matter: a model in a painter's studio, a subject that always manages to convey a feeling of art in progress.

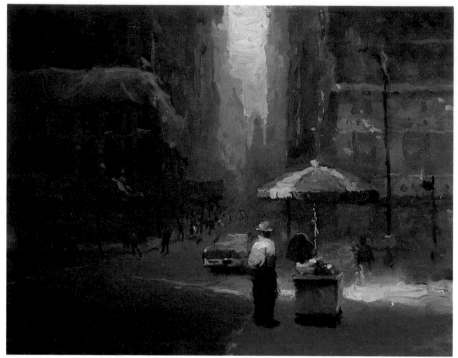

DOWNTOWN SABRETT MAN. 12" × 15" (30.5 × 38.1 cm). Private collection.

DOWNTOWN SABRETT MAN

This was an unusual lighting condition, and a fleeting one. I started this picture fairly late one afternoon, and these buildings in the Wall Street area of New York had blocked out most of the sunlight and thrown everything into purplish shadow. I used thin touches of purple and blue over a burnt sienna ground to convey a late afternoon look. Where the light sneaks through the buildings and is visible I used mainly thick orange and white paint. I also used thick paint for the sky in the distance, the man's shirt, and the umbrella. This contrast of thick against thin is one of the main things that makes the light really look like light.

ELGIN CORN AND FEED

The variety of paint textures is pretty evident here. The paint is thickest in the sky where the light is brightest. In the trees and on the ground the paint is applied more thinly. Around the gas pump the paint is so thin that the grain of the canvas shows through and suggests the density of grass. Canvas density is also used to convey the leafiness of the trees. I painted this picture in one afternoon in Elgin, Texas. The overcast lighting allowed me to work away without having to worry about any change of direction in the light source.

ELGIN CORN AND FEED. 12" × 16" (30.5 × 40.6 cm). Collection of John and Kitty Russell.

Index